VAN GOGH

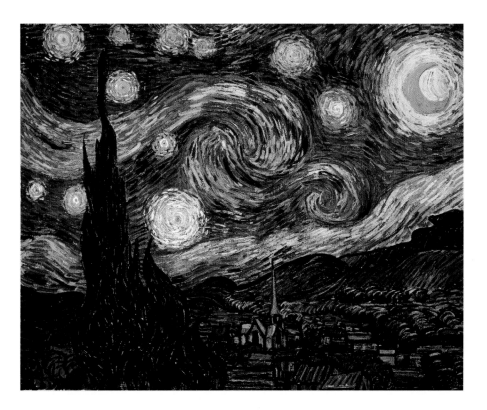

Published by Pulteney Press
1 Riverside Court
St Johns Road
Bath BA2 6PD

ISBN 978-1-906734-68-8

10 9 8 7 6 5 4 3 2 1

© Copyright 2009 Omnipress Limited

Designed and produced by Omnipress Limited, UK

Printed in Indonesia

Images were kindly supplied by Bridgeman Art Library, London.
Picture research: Alex Edouard

Postman Joseph Roulin (p.47)
1888
Oil on canvas
81.3 x 65.4 cm
Museum of Fine Arts, Boston
Gift of Robert Treat Paine, 2nd
35.1982

VAN GOGH

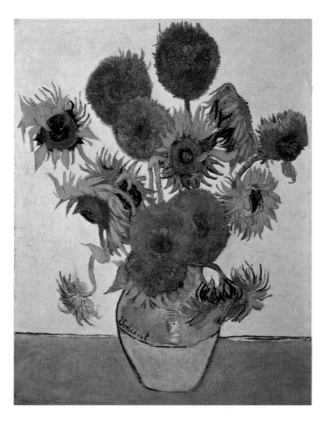

JANICE ANDERSON

PULTENEY
PRESS

Contents

CONTENTS

INTRODUCTION

VINCENT VAN GOGH painted pictures, mostly French landscapes and portraits, including self-portraits, in the Post-Impressionist style. During his short life, he sold only one of his paintings, while a handful of others found owners, most of whom were people willing to take van Gogh's pictures instead of payment for artists' materials, medical fees, or rent. Few of these recipients thought much of them. Dr Felix Rey, the intern who showed an interest in van Gogh's work in the hospital at Arles where he was a mental illness patient, thought so little of the portrait his patient had painted of him that he parted with it very cheaply. It was bought by the great Russian collector Sergei Shchukin in 1908, and *Portrait of Dr Felix Rey* (1889) is now a highly valued item in the Pushkin Museum in Moscow, the only van Gogh portrait in a Russian museum.

PORTRAIT OF DR FELIX REY
1889. Oil on canvas. 64 x 53 cm. Moscow Pushkin Museum.

Today, of course, the world views the work of Vincent van Gogh in a very different light. The Rijksmuseum Vincent van Gogh in Amsterdam, a gallery devoted solely to the artist's work, is one of the most visited in the world, and those paintings and drawings by van Gogh that have not found their way into great art galleries and museums are among the most sought-after, and therefore the most expensive items, in the art auction salerooms of the world.

If Vincent van Gogh had lived a decade or so longer – he was only 37 when he died of internal bleeding as the result a self-inflicted gunshot wound in 1890 – he would have witnessed the first moves in this extraordinary turn-round in the fortunes of his art. By the first decade of the twentieth century, the art world had woken up to the value of 'modern' artists, once sneered at for their 'impressions' and their other wildly painted canvases in which they flouted all traditional artistic values. But when he was born, in Groot-Zundert, near Brabant in the Netherlands in March 1853, there were still another 20 years or so to go before the work of Monet, Sisley, Renoir and the other Impressionists began to be noticed.

Vincent van Gogh was the eldest of six children born to a Protestant pastor. He inherited strong religious feeling from his father which, in his early twenties, led him into an assistant pastor's job in England in 1876 and caused him to think seriously about studying for a degree in theology at the University of Amsterdam in 1877. He also inherited strong feelings about life and nature, feelings shared by his younger brother Theo, that eventually took them both into the art world, initially as dealers. Theo was to be Vincent van Gogh's greatest supporter, and his greatest financial support, throughout his life as an artist. He was also the recipient of all van Gogh's hopes and fears, through 18 years of letter-writing, beginning in 1872 and only ending, more than 650 letters later, with van Gogh's death.

While Theo van Gogh remained an art dealer throughout his life, Vincent van Gogh spent four years in the Hague branch of the French art dealer Goupil et Cie, run by his uncle, from 1869 to 1873, followed by several months in the firm's London office and a year at Goupil in Paris. He left the art dealing world in 1876. In 1878 he enrolled at the Evangelical College in Brussels and within months had been taken on and subsequently dismissed from an assistant pastor's post in the Borinage in Belgium. The reason for his dismissal was 'over-zealous' behaviour – perhaps an early sign of the manic-depression that was to dog him for the rest of his life.

Van Gogh chose to remain in the Borinage until 1880, living and working among the poor people of a coal-mining village as an evangelist, but he also began to draw. He had always had a strong interest in art, and talked in his early letters to Theo about his admiration for the work of Millet. He concentrated on the life of the poor people of the region, trying to express his feelings for the lives of these poor people in his drawings and, later, on canvas. By 1880, his desire to paint far out-weighed his desire to follow a religious vocation, and he moved to Brussels, where he found a niche in the artistic community, concentrating on his drawing and becoming friendly with an already established artist; Count Anthony van Rappard.

In 1881, van Gogh moved back to the Netherlands, staying first at his parents' parsonage at Etten. He was to remain in The Netherlands for the next five years, greatly advancing his abilities as an artist but

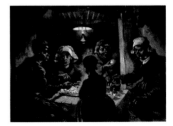

THE POTATO EATERS
Oil on canvas. 1888. 82 x 114 cm. Rijksmuseum Vincent van Gogh, Amsterdam.

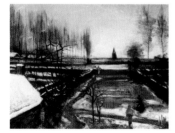

**THE PARSONAGE GARDEN
AT NUENEN IN WINTER**
*1885. Oil on canvas. 53 x 78 cm. Armand
Hammer Foundation.*

also suffering several set-backs in his personal life. He fell in love with his widowed cousin, Kee Vos-Stricker and was devastated when she curtly rejected him: 'Never, no, never' were the words she used to refuse his proposal of marriage. A major quarrel with his father saw Vincent van Gogh leaving home at the end of 1881 and moving to the Hague. Here, as well as beginning a deeply unsatisfactory relationship with a prostitute: Sien Hoornik, he studied watercolour painting with Anton Mauve, a man whose friendship he would later commemorate in the title of one of his most delightfully light-hearted works completed at Arles; *Souvenir de Mauve* (1888).

During his two years in The Hague, van Gogh began painting in oils, as well as watercolour. The paintings of this period are strongly, even confidently, painted, but they are also dark and quite heavy, features also notable in the oil paintings of 1884 and 1885. At this time he was back living with his parents in their parsonage at Nuenen, whose garden van Gogh painted several times, in such canvases as *The Parsonage Garden at Nuenen in Winter* (1885). It was during this time that he painted his first

really notable canvas, *The Potato Eaters* (1885), a study of a local peasant family gathered round the table for their evening meal. The setting is dark, with the eaters' faces lit by an oil lamp hanging above them. Their lives are clearly harsh, but there are strong bonds of affection between them, clearly brought out in the painting.

Following three months of study at the Academy of Fine Arts in Antwerp from the end of 1885, van Gogh made the momentous decision to return to Paris in March 1886, to stay with his brother Theo, who was manager of the Goupil (by now renamed Boussod, Valadon and Co.) Montmartre office. Although van Gogh had heard of the 'school, I believe, of Impressionists', as he remarked in a letter to Theo in 1883, he knew little about them in 1886. He would soon get to know a great deal about their work, as well as the artists in person.

One of his first acts upon arriving in Paris was to present himself at the studio of the liberal art teacher, Félix Cormon. Among Cormon's pupils were some greatly talented artists, including Henri de Toulouse-Lautrec, Emile Bernard and Paul Gauguin. It was the latter who introduced van Gogh

to Camille Pissarro, an artist whose work van Gogh (rather surprisingly) thought showed him to be the heir of Millet.

When he first saw the work of the established and by now successful Impressionists, such as Monet, Renoir, Sisley and Pissarro, van Gogh was not impressed: 'ugly, sloppily and badly painted, badly drawn, of a poor colour,' he wrote. Then he looked again, noting the lovely light-filled, bright atmosphere of Impressionism, the freedom and vigour of the short brushstrokes used to put pure colours on the canvas. He noted, too, the enormous amount of work the Impressionists did out-of-doors, in the fresh air. He went to work, feverishly painting canvas after canvas until his own palette lightened, his colours became brighter and his work took on a new freedom of expression. In the two years van Gogh was in Paris he painted approximately 110 paintings.

In the studio and at home in Theo's apartment, van Gogh painted still lifes. There were flower paintings, including wilting sunflowers gathered from fields and allotments; there were studies of simple objects in the apartment, such as his hob-nailed boots and *Still Life with Wine Bottle and Two Glasses* (1886). These works were very different from and much lighter than one of his last paintings in Antwerp, the extraordinary *Skull with a Burning Cigarette Between the Teeth* (1886). There were numerous self-portraits, one of which was painted on cardboard, stuck to a wood panel. Most of the self-portraits were painted in brushstrokes of pure colour, set close together, but still distinct from one another.

Out of doors, van Gogh carried his paints and canvases from one side of Paris to the other, and out into the countryside beyond, working *en plain air*. His palette lightened almost at once. *The Roofs of Paris*, painted just a month after his arrival in Paris in 1886, is notable for the creamy whites used to paint the cloudy sky and to add touches of light to the buildings of Paris. A year later, van Gogh was producing such wonderfully sun-lit paintings as *Fishing in Spring, Two Boats near a Bridge Across the Seine* (1887) and *The Ramparts of Paris near Porte de Clichy* (1887). By now, the broad strokes of full brushes of paint with which he had built up the sky in *The Roofs of Paris* had become short, light strokes and dots of pure colour.

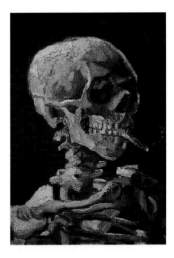

SKULL WITH BURNING CIGARETTE
1885/86. Oil on canvas. 32 x 24.5 cm. Antwerp, Amsterdam.

He was also painting the lives of the people he encountered. The restaurants he ate in were the subjects of several paintings, such as *Restaurant de la Sirène at Asnières* and *Interior of a Restaurant*, both painted in 1887. He also painted portraits of their owners, such as *Agostina Segatori in her Café du Tambourin* (1887). This habit of painting portraits of the people he met in daily life stayed with him and resulted in many superb portraits of the ordinary people of St Remy de Provence and Arles.

By early 1888, van Gogh, always restless, had tired of city life. He had also, like many of the Impressionists, fallen under the spell of Japanese prints, greatly admiring their composition, use of colour, and vibrancy. His *Portrait of Père Tanguy*, who sold artists' materials to many of the avant-garde artists in Paris, and which van Gogh painted in pure colours, straight from the tube, had a background composed of his own versions of Japanese prints.

Now, in the month in which he completed Père Tanguy's portrait, van Gogh decided he wanted warmth, sunshine and country landscapes and he also believed that in the landscape of the Midi he would find colours similar to those of Japanese prints. Perhaps

because of his intense, introspective nature – even his own family had thought him 'awkward' – he was drawn to nature and to the solitude of the countryside, where he could sense every change in colour and atmosphere, every detail of a flower and the insects on it, every waving wheatstalk in a field. He decided to leave the city and go to live in Provence, in the warm south of France.

After a last visit to the studio of the Impressionist artist Seurat in February 1888, van Gogh was seen off from the Gare du Midi by Theo for the long train ride down to Arles in Provence, where, he was sure, he would be able to set up his own studio. To his astonishment, he stepped off the train in Arles the next day into a white world of heavy snow and frost. For the first few days he had to stay in the room of the cheap hotel he had found within the medieval gateway of the Roman town. Fortunately, the view from his upper floor room was good enough to allow him to start painting at once: the pork butcher's shop seen from his window and a small branch of blossoming almond in a glass of water, for instance.

Within days, the weather had cleared and van Gogh, having received 100 francs from his brother, half of which he immediately

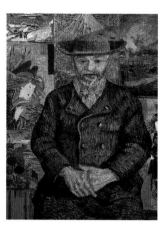

PÈRE TANGUY (FATHER TANGUY)
1887/8. Oil on canvas. 47 x 38.5 cm. Musée Rodin, Paris, France.

spent on canvases and paints, set out into the open air in search of subjects. In the following months he paint dozens, even hundreds of pictures that are now widely regarded as masterpieces. 1888 was the year that van Gogh painted such works as *The Gypsy Encampment, Harvest Landscape, Fourteen Sunflowers in a Vase* (one of van Gogh's many versions of the subject), *Fishing Boats on the Beach, Café Terrace at Night, Postman Rolin* and *The Arlesienne, Madame Ginoux with Books.*

While all these paintings are now in the world's great art galleries, some idea of their value in the modern world can be guessed from the fact that a version of *The Arlesienne, Madame Ginoux* still in private hands had an asking price of $40 million when it was put up for auction in New York in 2006. This sum becomes less astonishing when one learns that van Gogh's 1890 *Portrait of Dr Gachet* sold for $82.5 million in 1990.

The Arlesienne, Madame Ginoux is of particular interest in the story of Vincent van Gogh because he painted it for his friend Paul Gauguin. It was Theo van Gogh, who was worried about his brother's lonely and rather frenzied life in Arles, that persuaded Gauguin to make an extended stay in Arles with him. Rather reluctantly, Gauguin did go to Arles, staying with van Gogh in a little yellow house, naturally the subject of a painting, *The Yellow House (Vincent's House)* (1888), from October to December 1888. To make the house really welcoming, Van Gogh covered the walls with paintings of vases of bright yellow sunflowers.

At first, all went well. The two artists spent most of their time painting, in the house – even their chairs became subjects for van Gogh's canvases, in Arles and out in the countryside. Several of van Gogh's paintings, such as *Spectators at the Arena at Arles* (1888), were deliberately painted in Gauguin's more forceful, rather hard-edged style in a sort of homage to his friend. By now, van Gogh was using colour, as he said himself, 'more arbitrarily so as to express myself more forcibly'. Where the Impressionists used colour to reproduce visual objects as naturally as possible, van Gogh used them for their symbolic and expressive values.

By the end of 1888, van Gogh, who had been experiencing nervous crises and hallucinations for some time, was moving close to mental breakdown. Gauguin

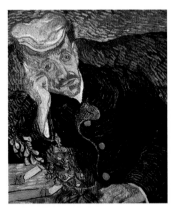

PORTRAIT OF DOCTOR GACHET
1890. Oil on canvas. 67 x 56 cm. Private collection.

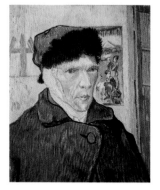

SELF-PORTRAIT WITH BANDAGED EAR AND PIPE

1889. Oil on canvas. 60 x 49 cm. Samuel Courtauld Trust, Courtauld Institute of Art Gallery.

thought him quite dangerous, and left the house after one particularly fraught evening in van Gogh's company. In the personal crisis that followed, van Gogh cut off part of his left ear, an incident he portrayed in the strikingly coloured *Self-portrait with Bandaged Ear and Pipe* (1889). From this time until his death in July 1890, he suffered intermittent attacks of severe depression and mental disturbance.

After the ear-cutting incident, van Gogh spent some weeks, spread over two periods, in the hospital at Arles, where he was treated with great care by a young doctor, Felix Rey. Knowing that he needed real psychiatric help, van Gogh requested that he be allowed to enter a mental asylum at St Remy, near Arles, in May 1889. He stayed there for a year, continuing to paint pictures in a near-frenzy of activity, with many of the paintings becoming great swirls of thick paint and blocks of vivid complementary colours.

Among the 150 paintings he did during this hyper-active year were several paintings of the asylum, its gardens and its occupants and staff. Outside, he depicted the countryside of Provence in paintings that have become an archetypal vision of the region, among them *The Starry Night*, *Wheat Field with Cypresses*, *Irises* and the several paintings called *Enclosed Field with Reaper*.

Van Gogh was released from the asylum in St Remy on 16 May 1890, apparently 'cured'. He had decided to return to the north of France and left that same day for Paris. Once in the capital, he stayed with Theo, now married and with a son, also called Vincent. While van Gogh was pleased to see several of his paintings, including *The Potato Eaters* and a large *Landscape from Arles*, hanging in the apartment, but he was distressed to see dozens more of his paintings stacked up in corners, behind doors and under beds. Even such a good and experienced art dealer as Theo van Gogh could not sell them.

He put on a brave face, however, Theo's wife, Jo, remarked that van Gogh looked very well: 'a strong, broad-shouldered man with a healthy colour, a smile on his face.' Three days later, unable to bear the noise of the city, van Gogh travelled to Auvers-sur-Oise, a village long favoured by artists, about 20 miles north-west of Paris.

Camille Pissarro had told him that while there he should put himself in the care of a very good doctor and homeopathic specialist, Paul-Ferdinand Gachet.

Fortunately for van Gogh, whose poverty would allow him to rent only a cheap garret in the local inn at Auvers, he got on very well with Dr Gachet, and spent much time with him. Naturally, he painted portraits of Dr Gachet, his daughter, Marguerite and numerous pictures of life in their house and garden. He also painted several wonderfully unsentimental, cheerfully realistic pictures of children. He spent as much time as possible out-of-doors, painting in the village, depicting its church, its streets and houses, as well as in the fields around Auvers.

As in the South of France, so at Auvers, van Gogh painted almost non-stop: he amassed 70 oil paintings and 30 watercolours and other drawings in less than 12 weeks. So many of the paintings of van Gogh's last weeks are marked by a wonderful lightness of spirit – *Landscape with Carriage and Train in the Background*, for instance, or *Daubigny's Garden with Black Cat* – that the return of the depression that caused him to try to shoot himself in a field – probably the field in *Wheat Field Under Threatening Skies with Crows* – comes as a terrible shock to anyone looking at his Auvers paintings.

At first, van Gogh's wound was not thought to be life-threatening, but he was bleeding internally, and on 29 July 1890, two days after he had shot himself, van Gogh died, his brother Theo at his side. He was buried in the graveyard of the church at Auvers, which he himself had painted, set against a deep blue sky, just one month before.

WHEATFIELD WITH CROWS
1890. Oil on canvas. 50.5 x 103 cm. Van Gogh Museum, Amsterdam, the Netherlands.

Plate 1

MAN WITH A SPADE RESTING

Pencil and chalk. 1882. Private collection.
41 x 58 cm.

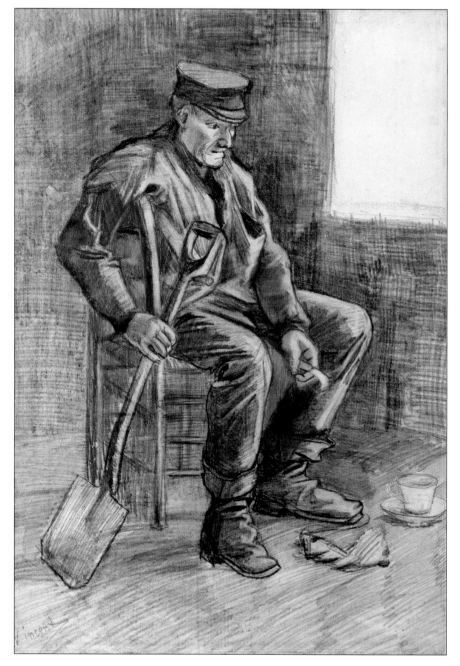

Pen transferred to lithograph. 1883. Private collection.

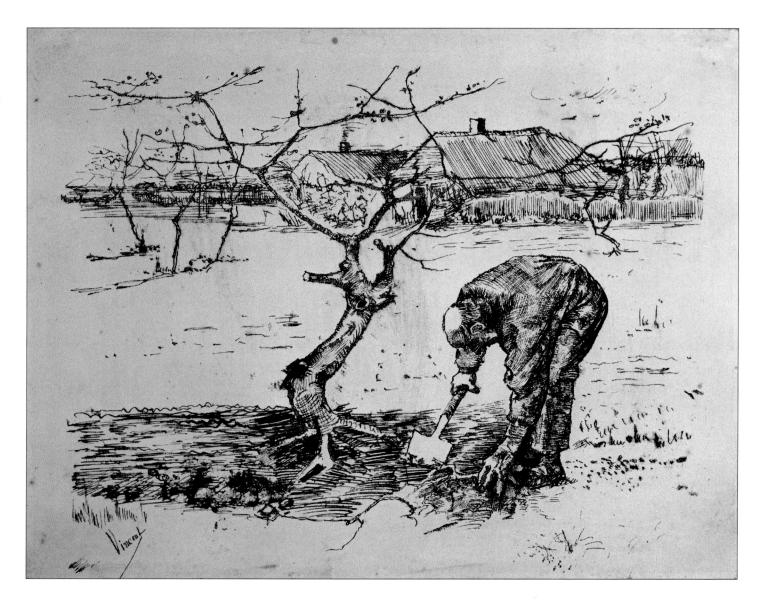

Plate 3

OLD MAN WITH A PIPE

Pen and ink and charcoal. 1883. Haags Gemeentemuseum,
the Hague, Netherlands. 26 x 46 cm.

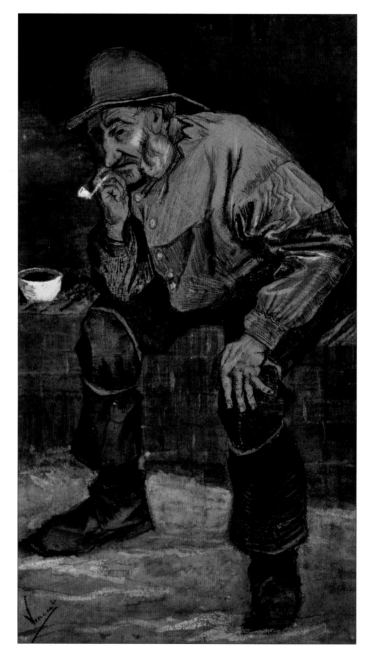

Plate 4

THE POTATO EATERS

Oil on canvas. 1885. Stedelijk Museum, Amsterdam.
81.5 x 114.5 cm

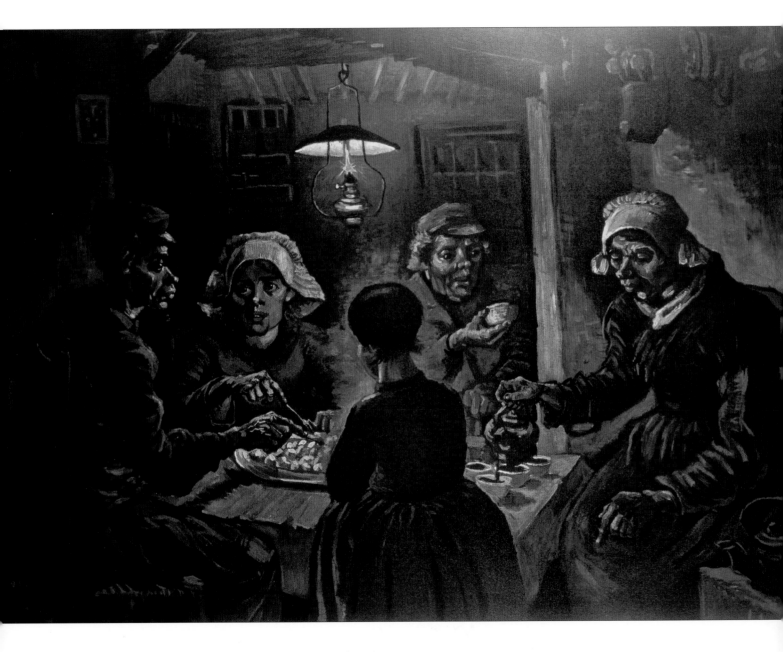

Plate 5

THE PARSONAGE GARDEN AT NUENEN IN WINTER

Oil on canvas. 1885. Armand Hammer Foundation, USA.
53 x 78 cm.

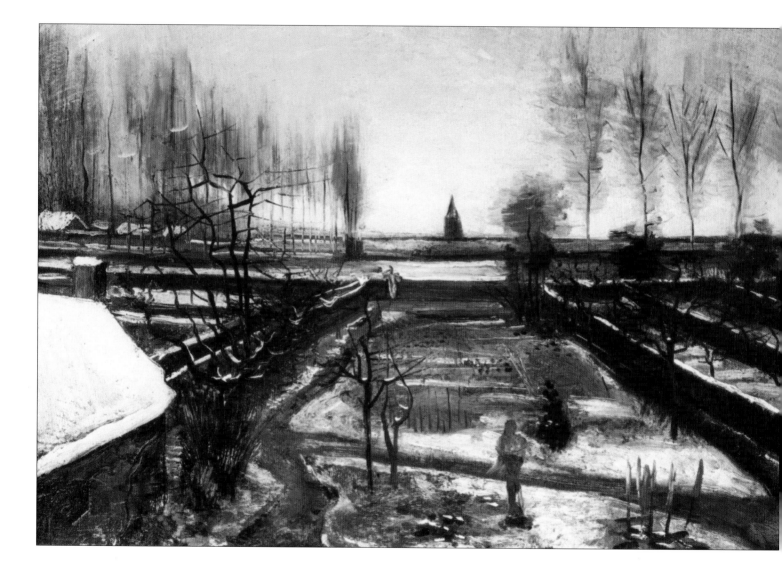

STILL LIFE WITH FLOWERS

Plate 6

Oil on canvas. c.1886. Museo de Arte, Sao Paulo.
54 x 45 cm.

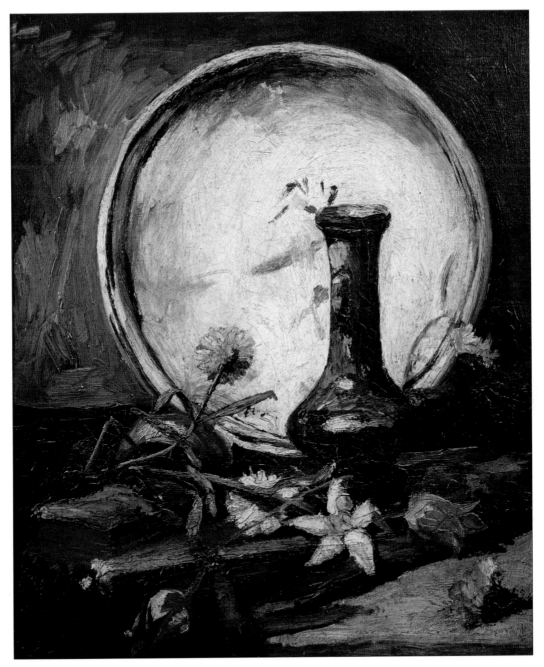

Plate 7

LE MOULIN DE BLUTE–FIN

Oil on canvas. 1886. Glasgow City Art Gallery & Museum.
46 x 38 cm.

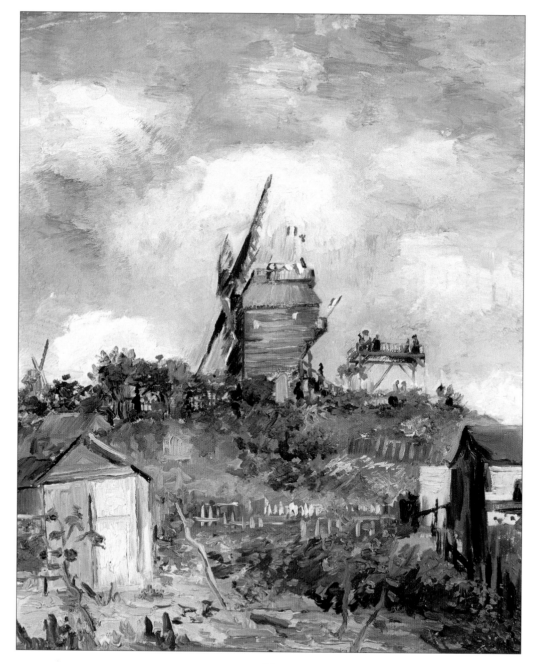

Restaurant de la Sirène at Asnières

Plate 8

Oil on canvas. 1887. Musée d'Orsay, Paris.
65 x 54 cm.

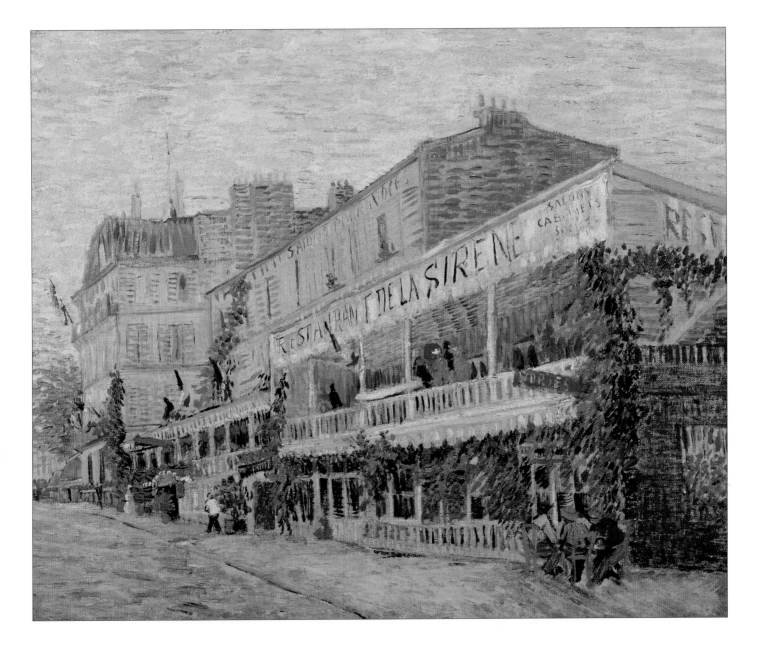

Plate 9

THE ARTIST'S MOTHER

Oil on canvas. 1888. Private collection. 40.5 x 32.5 cm.

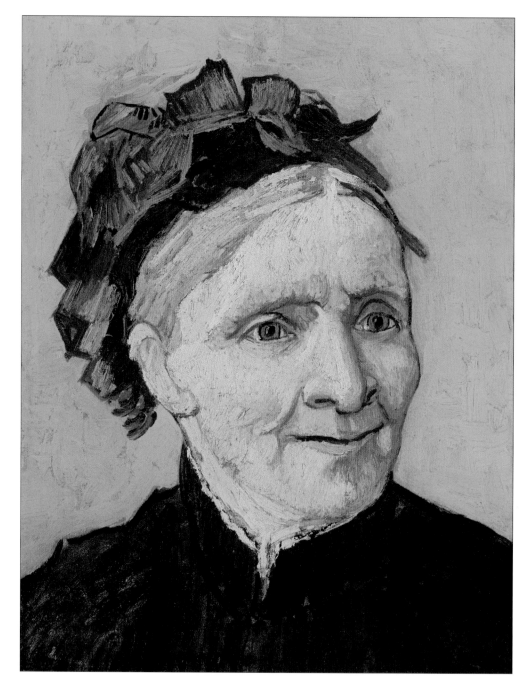

PORTRAIT OF ALEXANDER REID

Plate 10

Oil on cardboard. 1887. Art Gallery and Museum, Kelvingrove, Glasgow, Scotland.
41.5 x 33.5 cm.

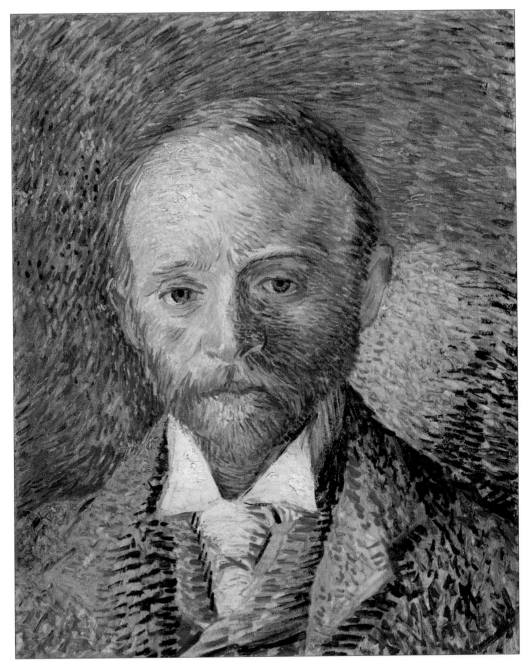

Plate II

FISHING IN THE SPRING, PONT DE CLICHY

Oil on canvas. 1887. Art Institute of Chicago, IL, USA.
56 x 49 cm.

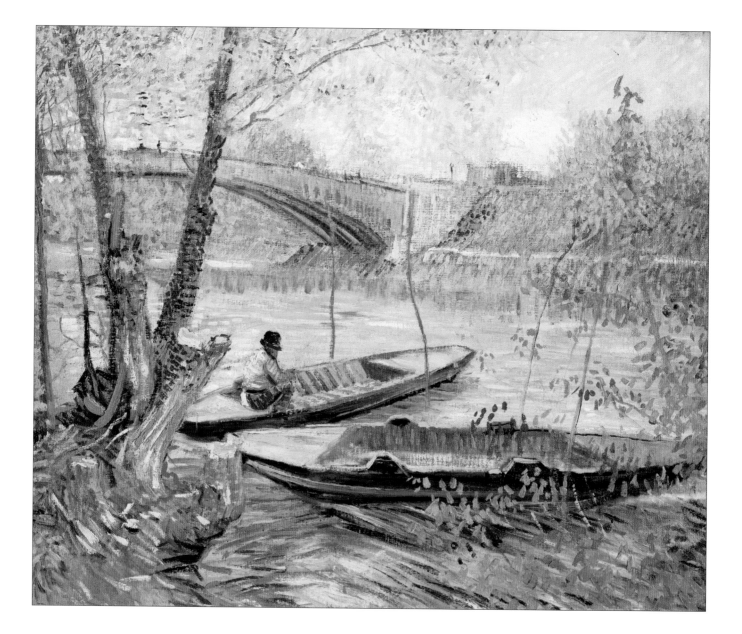

WOMAN IN THE 'CAFE TAMBOURIN'

Plate 12

Oil on canvas. 1887. Rijksmuseum Kroller-Muller, Otterlo, Netherlands.
55.5 x 46.5 cm.

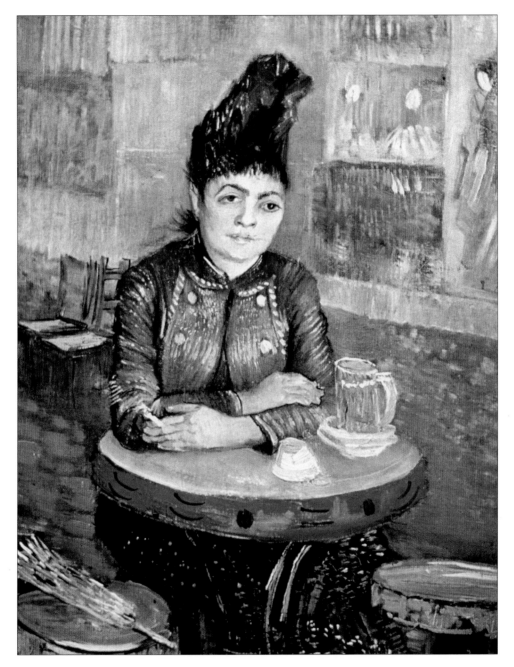

Plate 13

STILL LIFE

Oil on canvas. 1887. Van der Heydt Museum, Wuppertal, Germany. 41 x 38 cm.

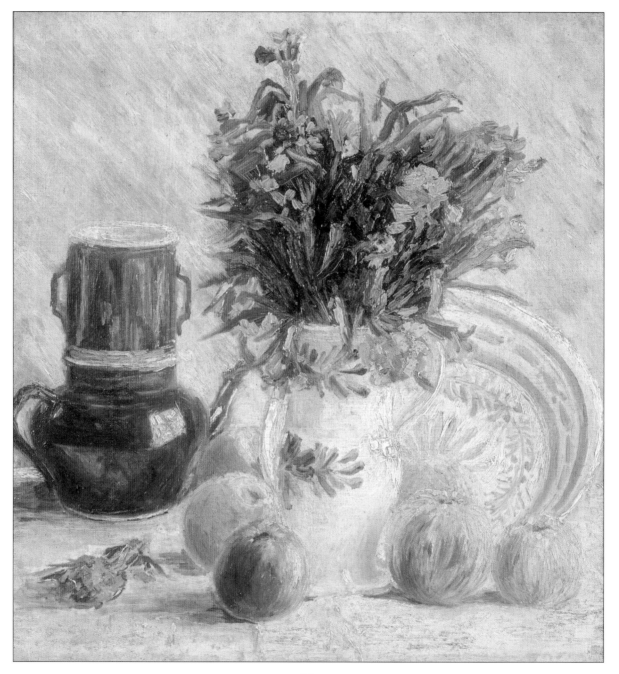

SELF PORTRAIT WITH FELT HAT

Plate *14*

Oil on canvas. 1887–88. Van Gogh Museum, Amsterdam.
41 x 32 cm.

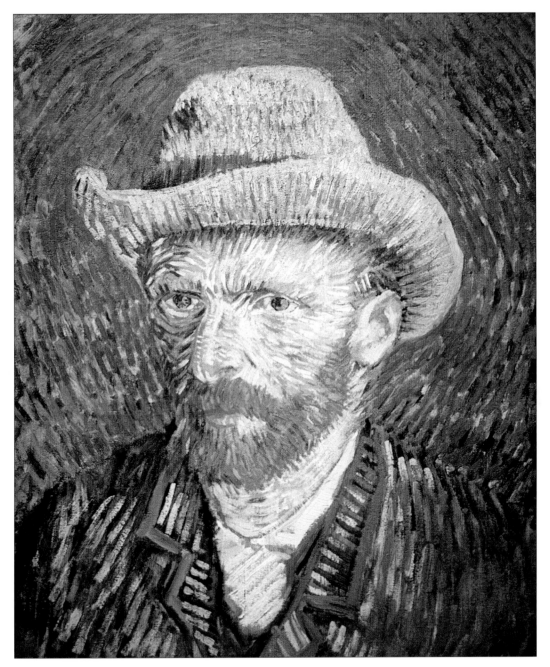

Plate 15

WHEATFIELD WITH LARK

Oil on canvas. 1887. Van Gogh Museum, Amsterdam.
54 x 64.5 cm.

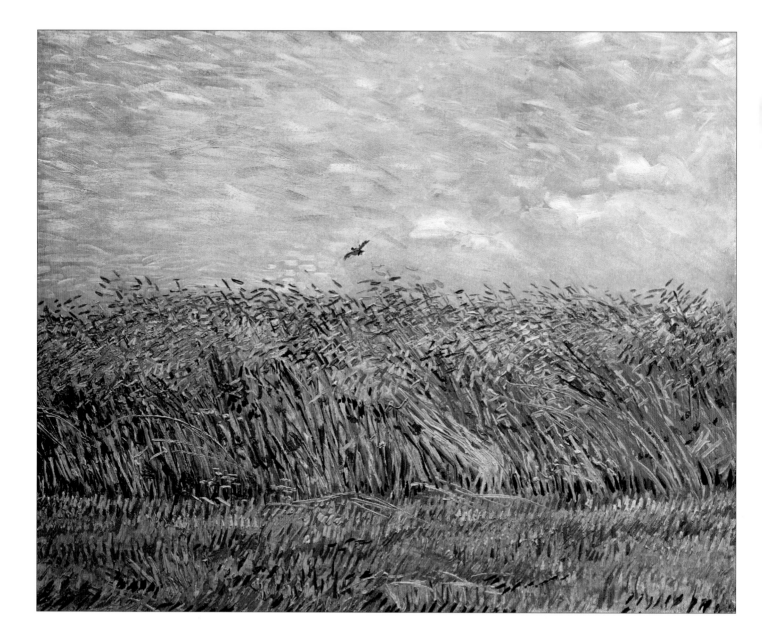

SUNFLOWERS

Plate 16

Oil on canvas. 1887. Metropolitan Museum of Art, New York, USA.
61 x 43 cm.

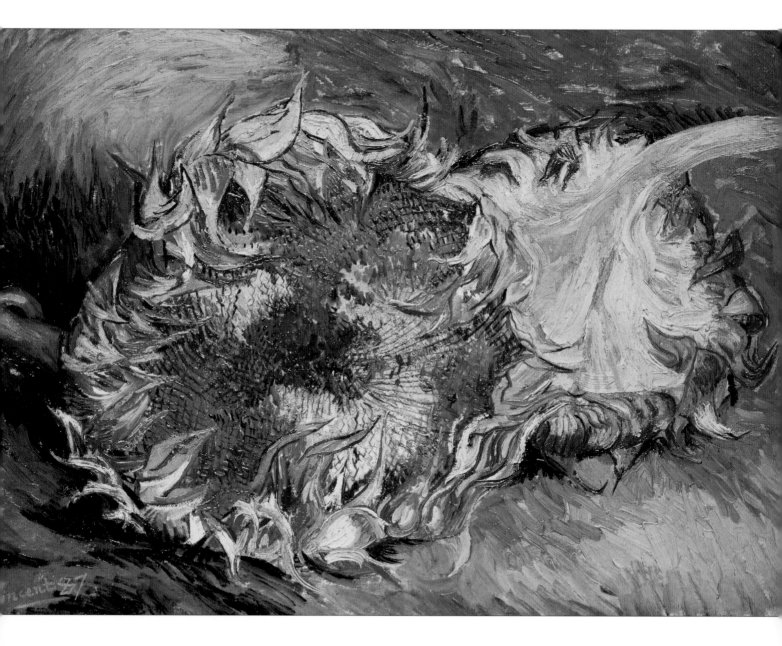

Plate 17

FOUR WITHERED SUNFLOWERS

Oil on canvas. 1887. Rijksmuseum Kroller-Muller, Otterlo, Netherlands.
60 x 100 cm.

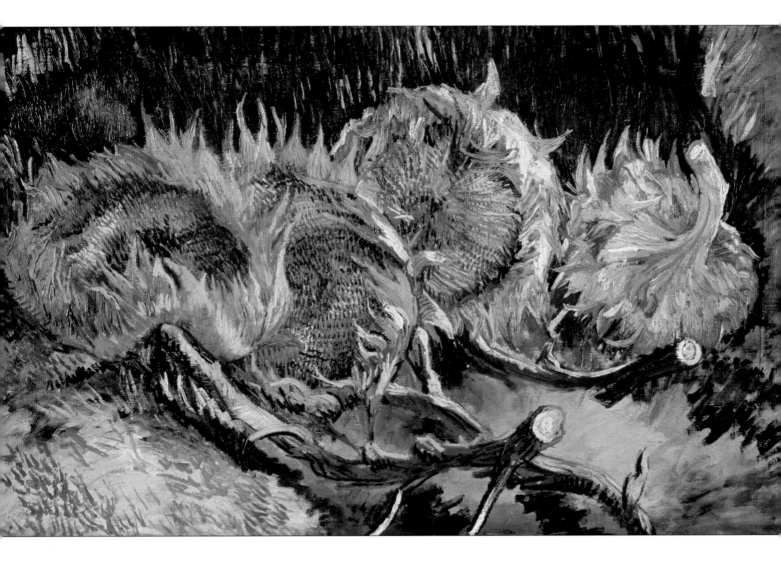

Plate 18

PÈRE TANGUY (FATHER TANGUY)

Oil on canvas. 1887-8. Musée Rodin, Paris, France.
51 x 61 cm.

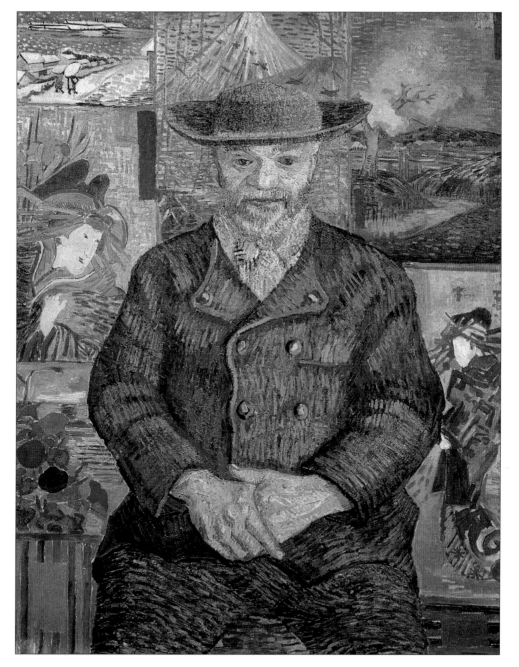

Plate *19*

THE ITALIAN: AGOSTINA SEGATORI

Oil on canvas. 1887. Musée d'Orsay, Paris, France. 81 x 60 cm.

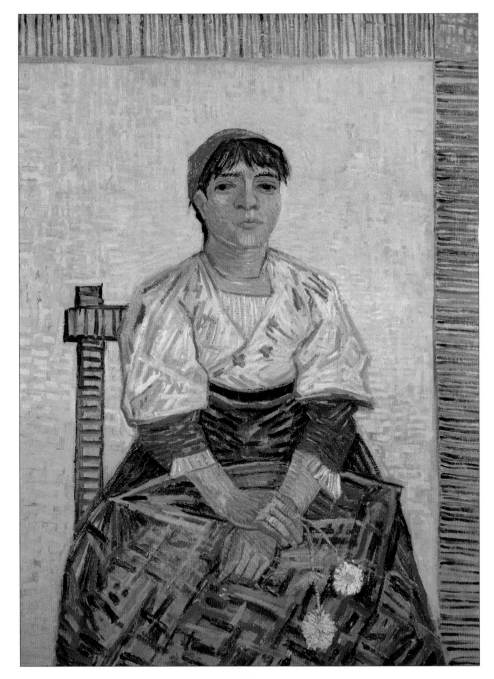

Oil on canvas. 1887. Private collection. 92 x 73 cm.

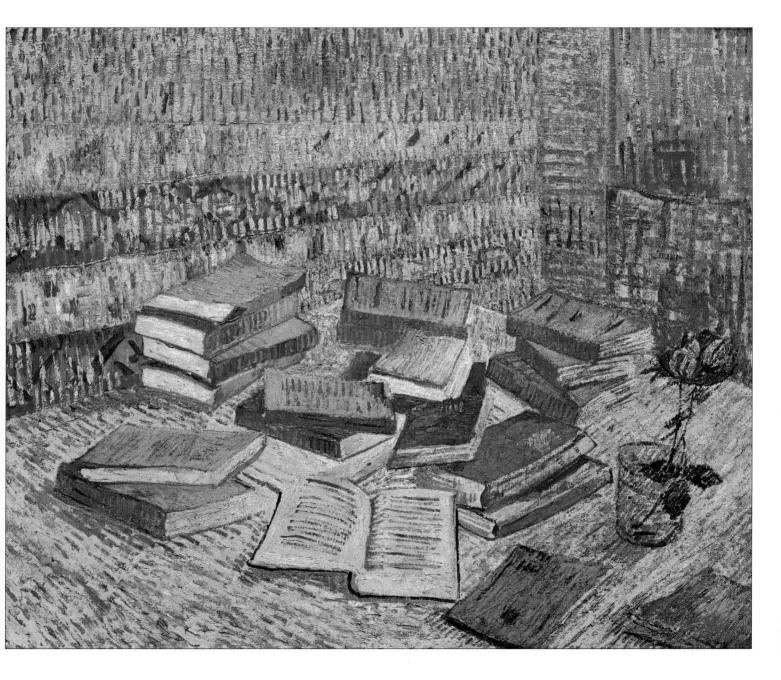

Plate 21

TREES AND UNDERGROWTH

Oil on canvas. 1887. Van Gogh Museum, Amsterdam, the Netherlands.
46.5 x 55.5 cm.

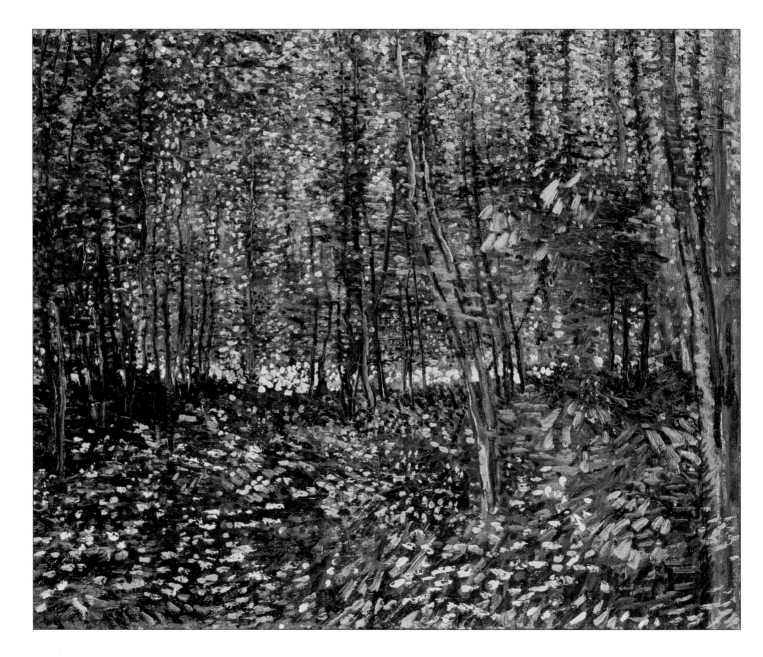

Plate 22

SELF PORTRAIT AS AN ARTIST

Oil on canvas. 1888. Van Gogh Museum, Amsterdam. 65 x 50.5 cm.

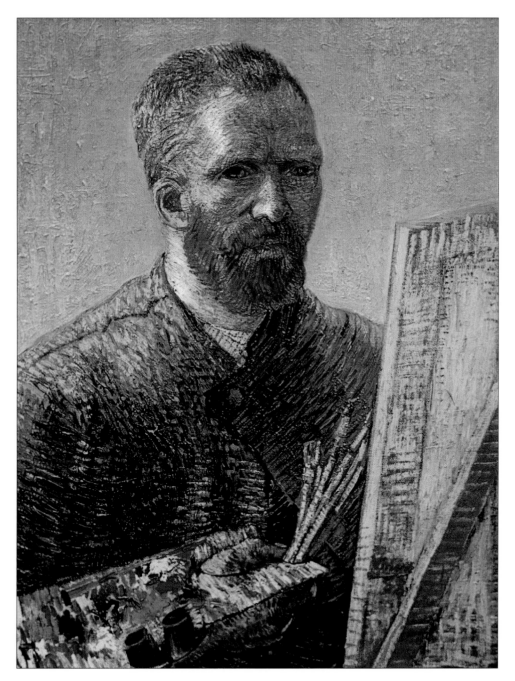

Plate 23

THE CARAVANS, GYPSY ENCAMPMENT NEAR ARLES

Oil on canvas. 1888. Musée d'Orsay, Paris, France. 51 x 45 cm.

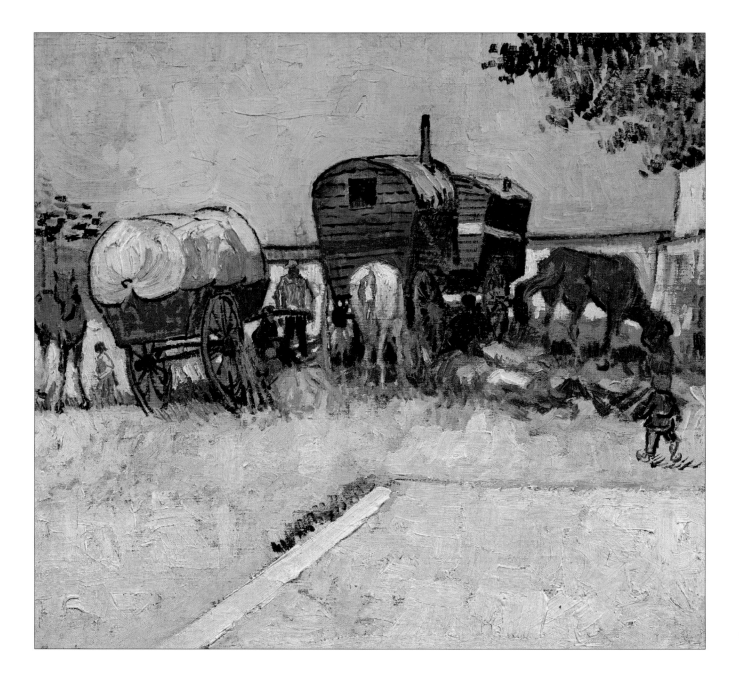

Oil on canvas. 1888. National Gallery, London, UK. 95 x 73 cm.

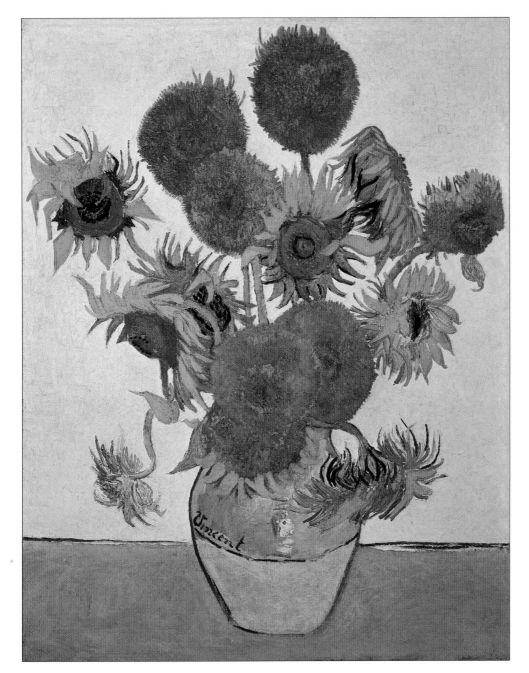

Plate 25

MAS AT SAINTES-MAIRIES

Oil on canvas. 1888. Private collection.
30.5 x 47 cm.

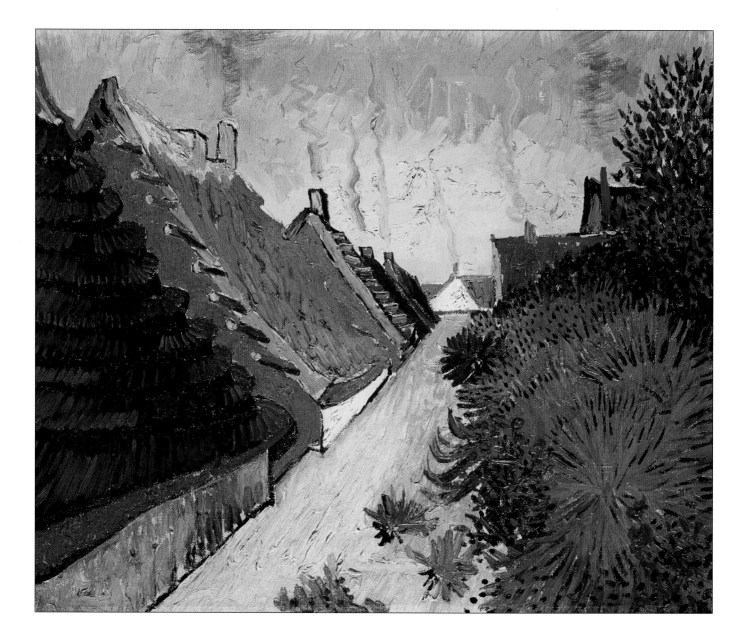

Plate 26

THE ARENA AT ARLES

Oil on canvas. 1888. Hermitage, St. Petersburg, Russia.
92 x 73 cm.

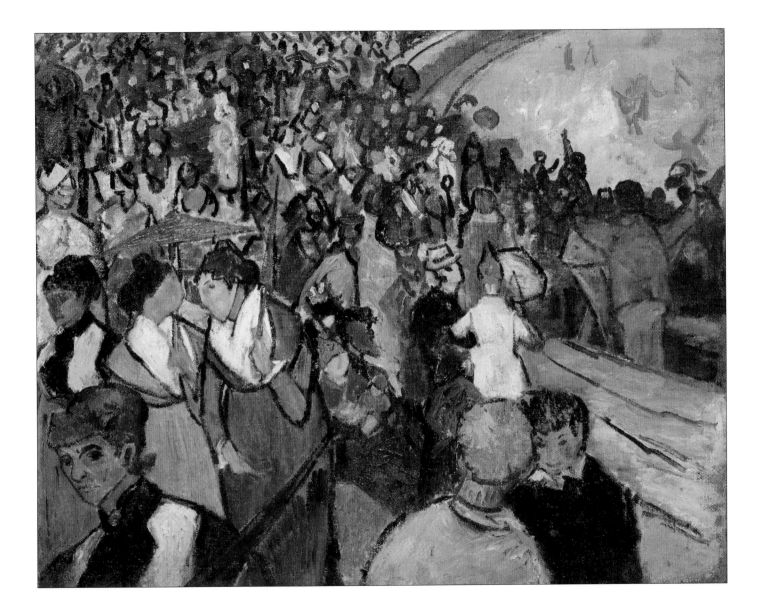

Plate 27

THE DANCE HALL AT ARLES

Oil on canvas. 1888. Musée d'Orsay, Paris, France.
81 x 65 cm.

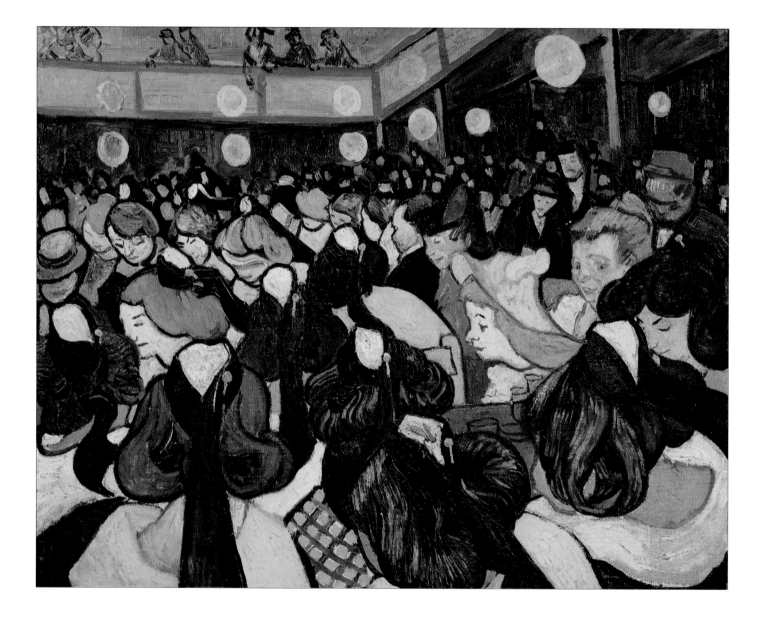

Oil on canvas. 1888. Private collection. 65 x 81 cm.

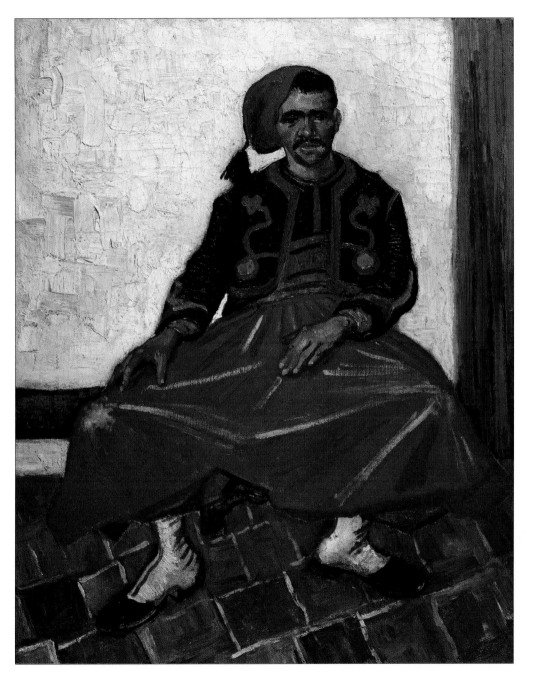

Plate 29

CAFE TERRACE, PLACE DU FORUM, ARLES

Oil on canvas. 1888. Rijksmuseum Kroller-Muller, Otterlo, Netherlands.
81 x 65.5 cm.

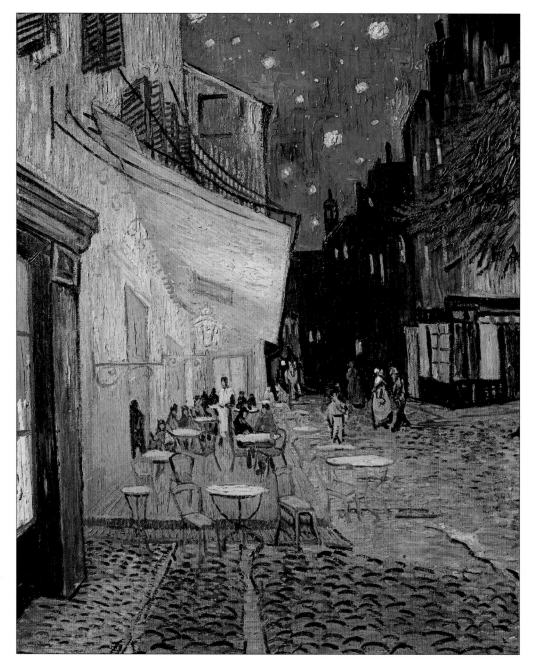

THE NIGHT CAFE IN ARLES

Watercolour on paper. 1888. Professor Hans R. Hahnloser Collection, Bern, Switzerland.
70 x 89 cm.

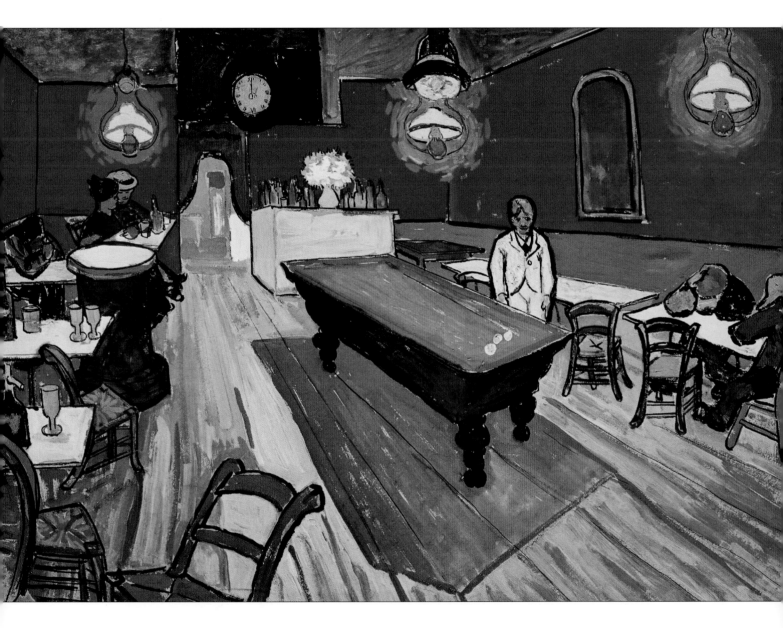

Plate 31

SELF PORTRAIT DEDICATED TO PAUL GAUGUIN

Oil on canvas. 1888. Fogg Art Museum, Harvard University Art Museum, USA.
62 x 52 cm.

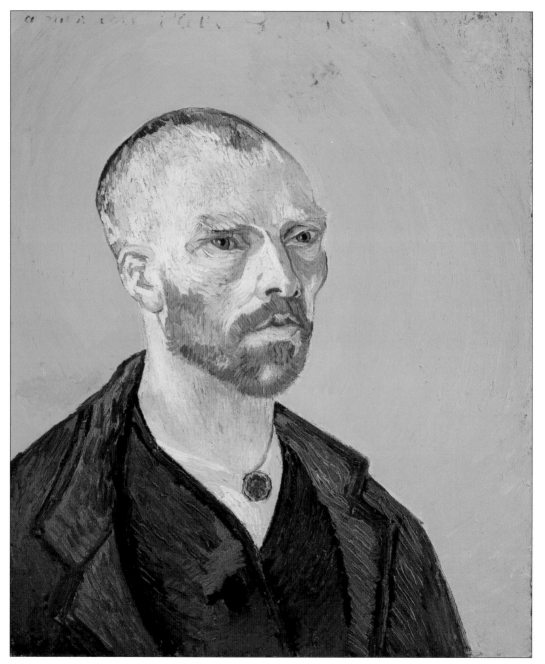

Plate 32

ALLÉE DES ALYSCAMPS IN ARLES

Oil on canvas. 1888. Private collection. 28 x 36 cm.

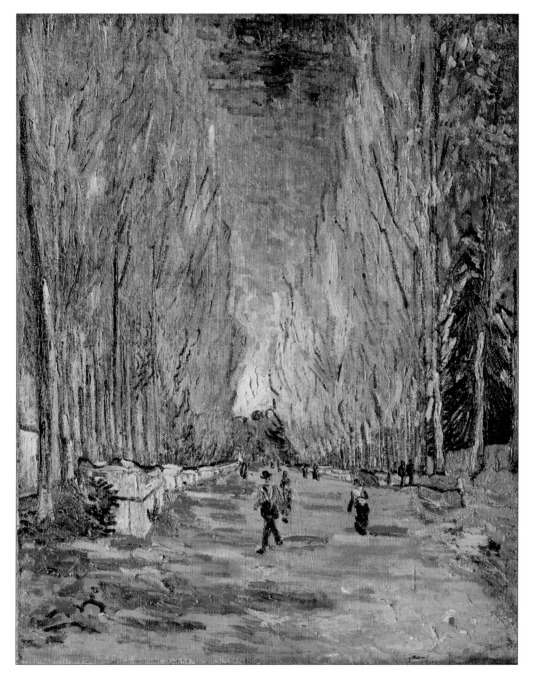

Plate 33

ENTRANCE TO THE PUBLIC GARDENS IN ARLES

Oil on canvas. 1888. Phillips Collection, Washington DC, USA.
72.5 x 91 cm.

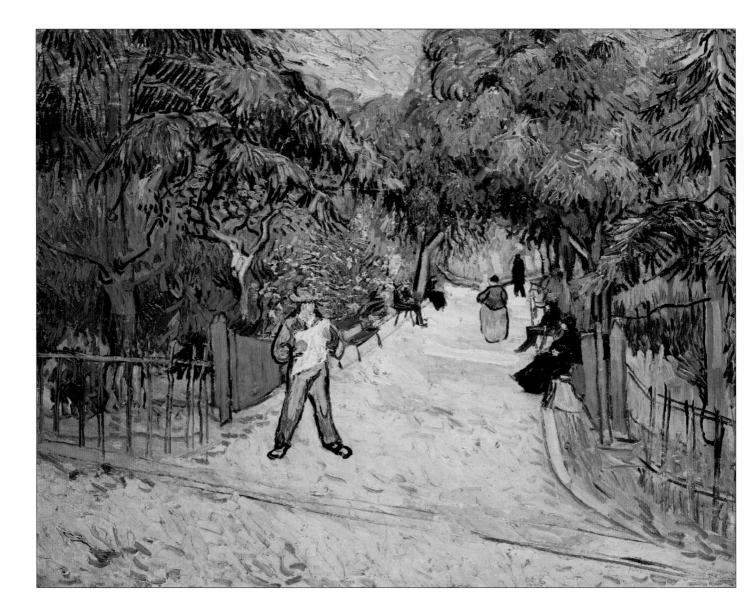

Oil in canvas. 1888. Museum of Fine Arts, Boston, Massachusetts. 81 x 65 cm.

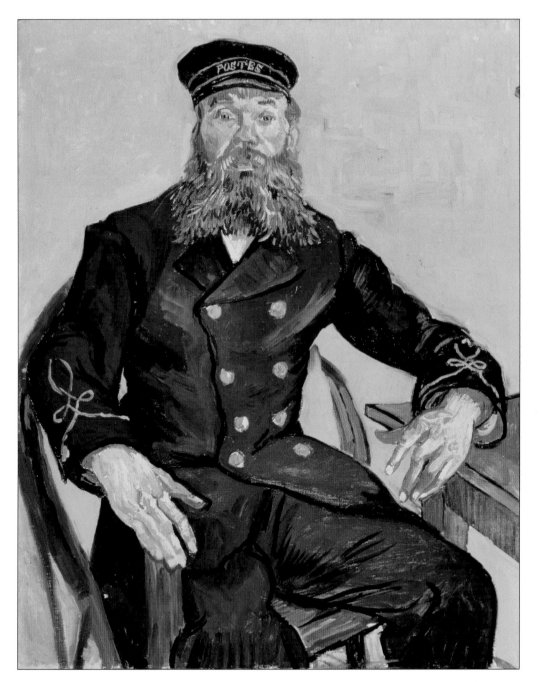

Plate 35

L'ARLESIENNE (MADAME GINOUX)

Oil on canvas. 1888. Metropolitan Museum of Art, New York, USA.
72 x 90 cm.

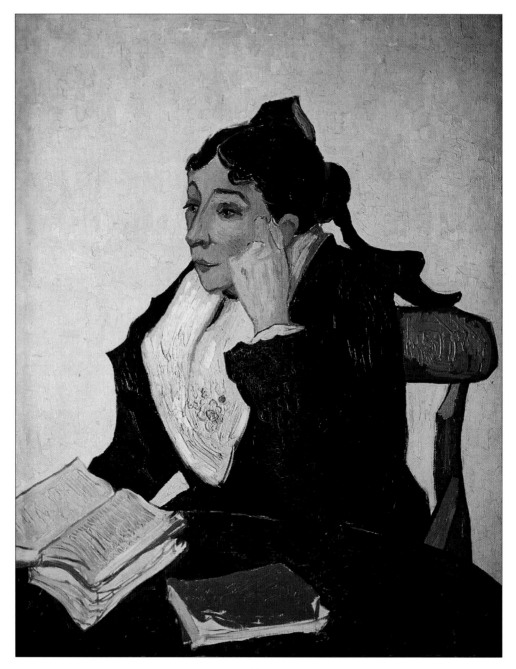

Plate 36

ORCHARD IN BLOSSOM (PLUM TREES)

Oil on canvas. 1888. National Gallery of Scotland, Edinburgh.
55 x 65 cm.

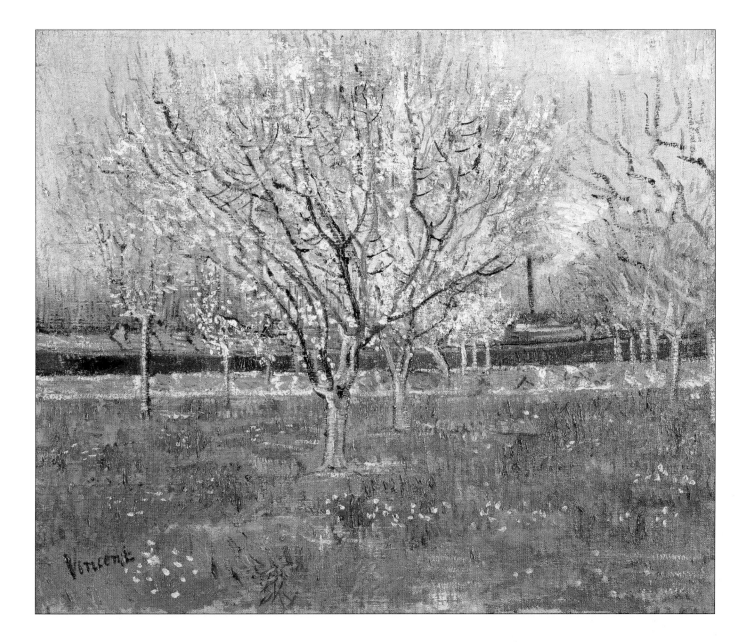

Plate *37*

THE STARRY NIGHT

Oil on canvas. 1888. Musée d'Orsay, Paris.
92 x 72 cm.

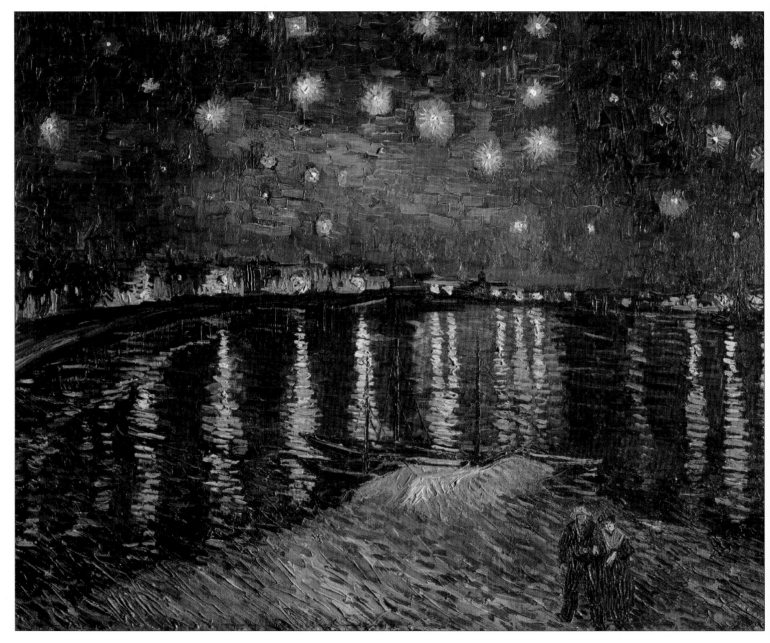

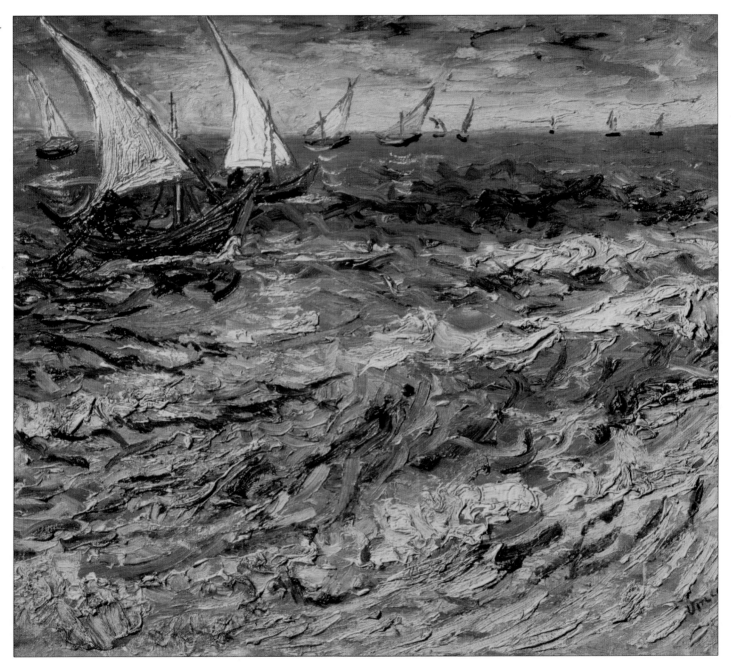

Plate 39

THE YELLOW HOUSE

Oil on canvas. 1888. Van Gogh Museum, Amsterdam, the Netherlands.
72 x 91.5 cm.

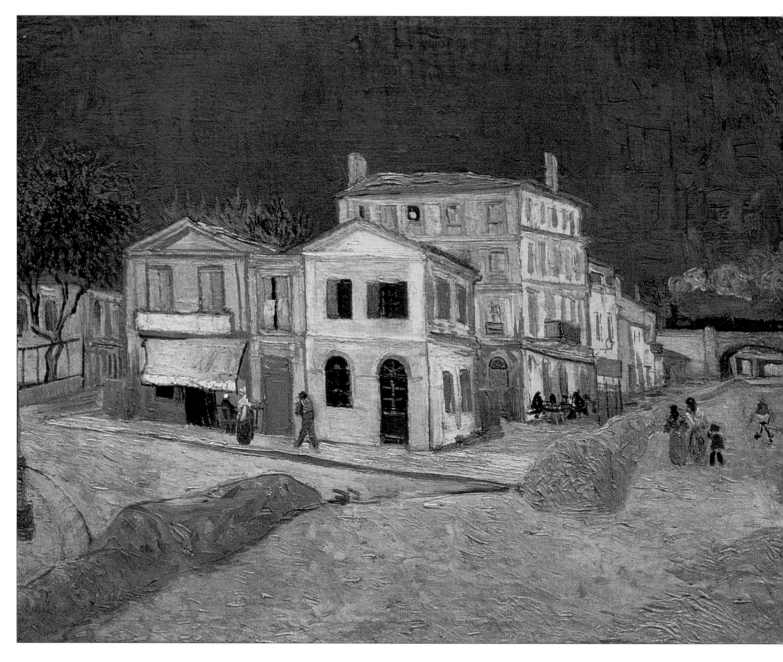

Oil on canvas. 1888. National Gallery, London, UK. 93 x 73.5 cm.

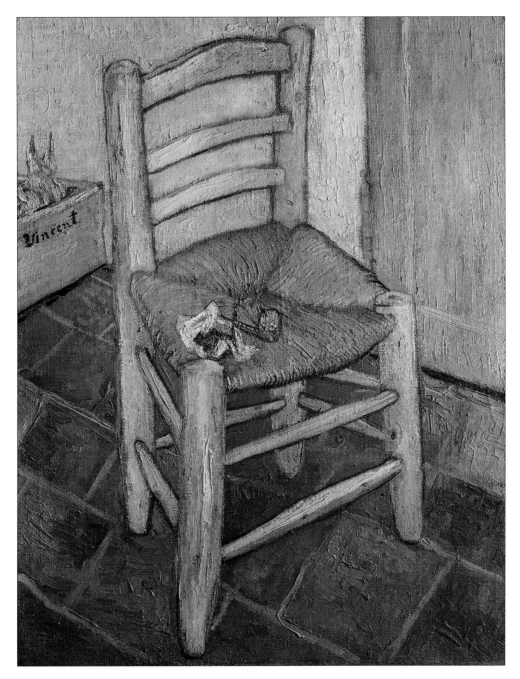

Plate 41

COUPLE IN THE PARK, ARLES

Oil on canvas. 1888. Private collection.
73 x 92 cm.

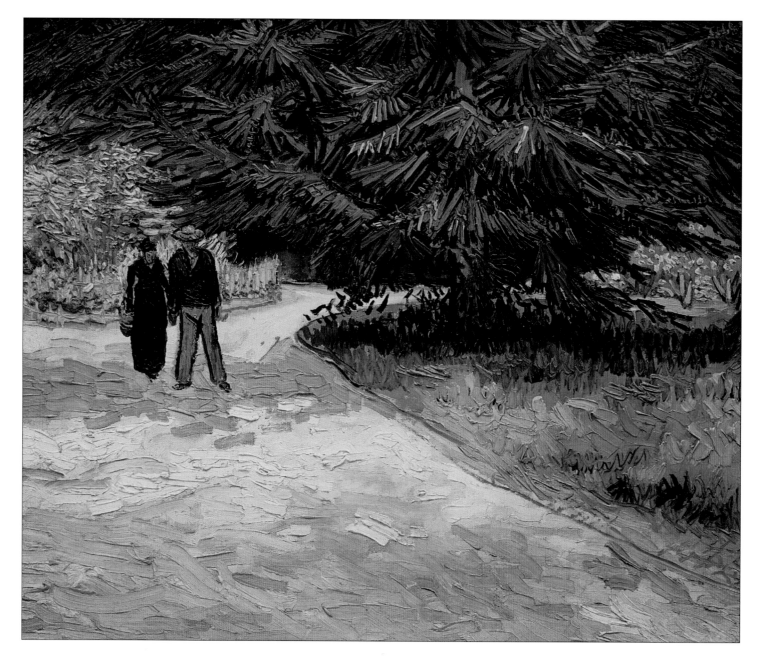

PORTRAIT OF EUGENE BOCH

Plate 42

Oil on canvas. 1888. Musée d'Orsay, Paris, France. 45 x 60 cm.

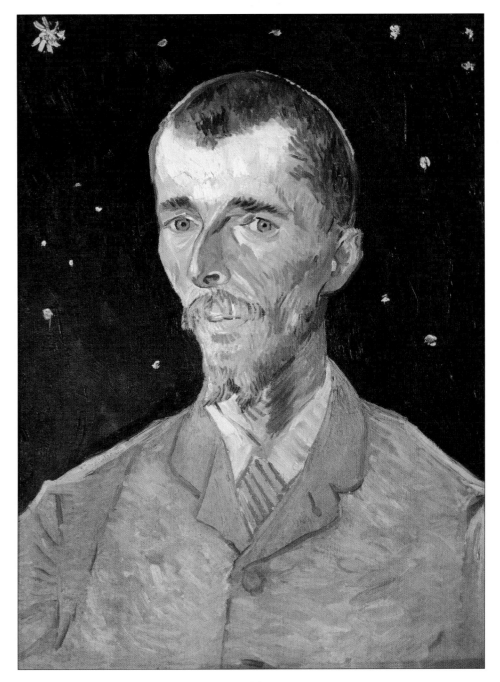

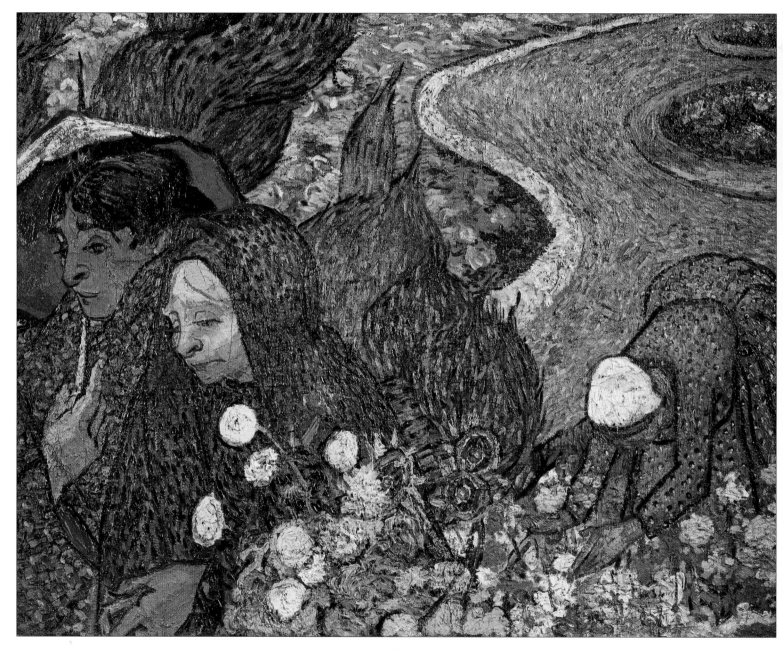

LANDING STAGE WITH BOATS

Oil on canvas. 1888. Museum Folkwang, Essen, Germany.
66 x 55 cm.

Plate 44

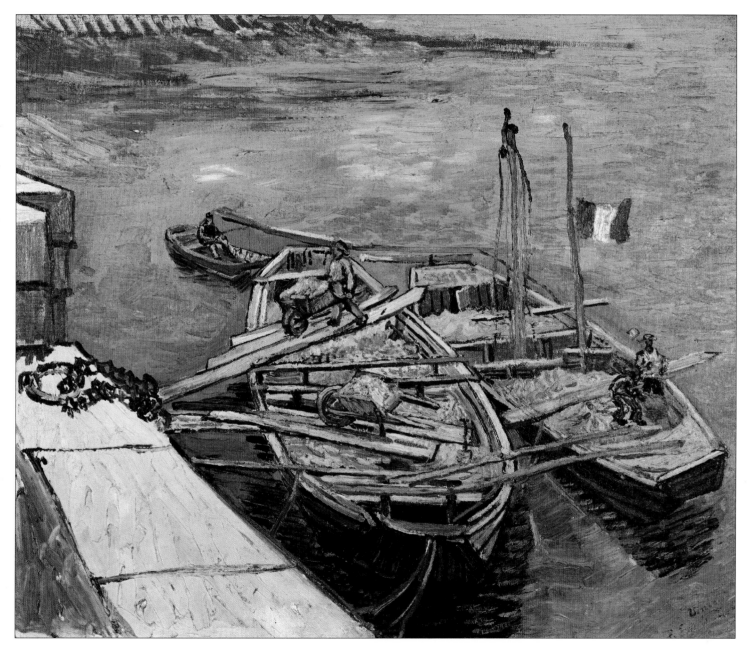

Plate 45

POLLARDED WILLOWS AND SETTING SUN

Oil on card. 1888. Rijksmuseum Kroller-Muller, Otterlo, Netherlands.
34 x 32 cm.

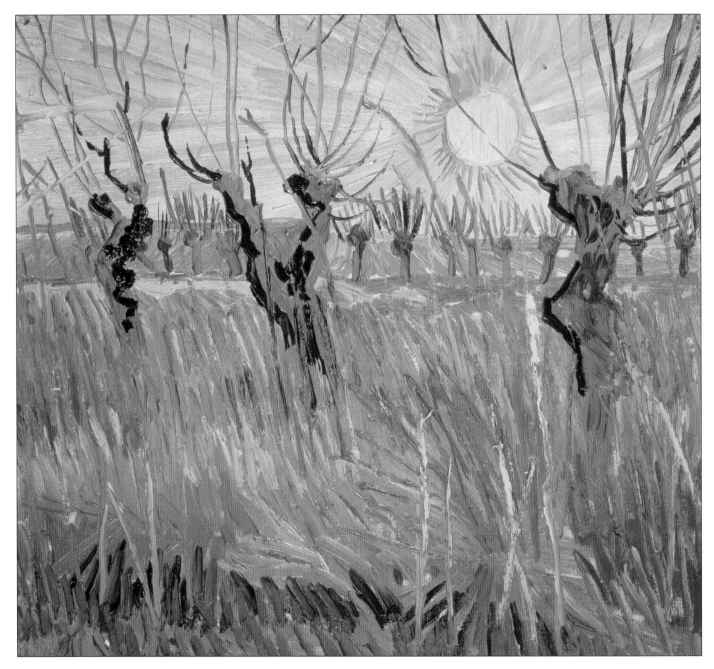

RED VINEYARDS AT ARLES

Plate 46

Oil on canvas. 1888. Pushkin Museum, Moscow, Russia.
93 x 75 cm.

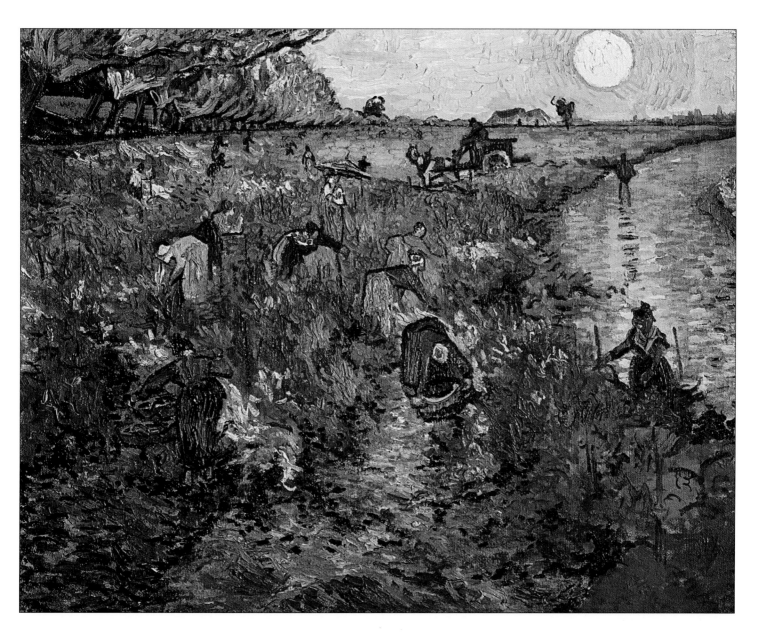

Plate 47

THE ROAD MENDERS

Oil on canvas. 1889. Phillips Collection, Washington DC, USA.
73.7 x 92 cm.

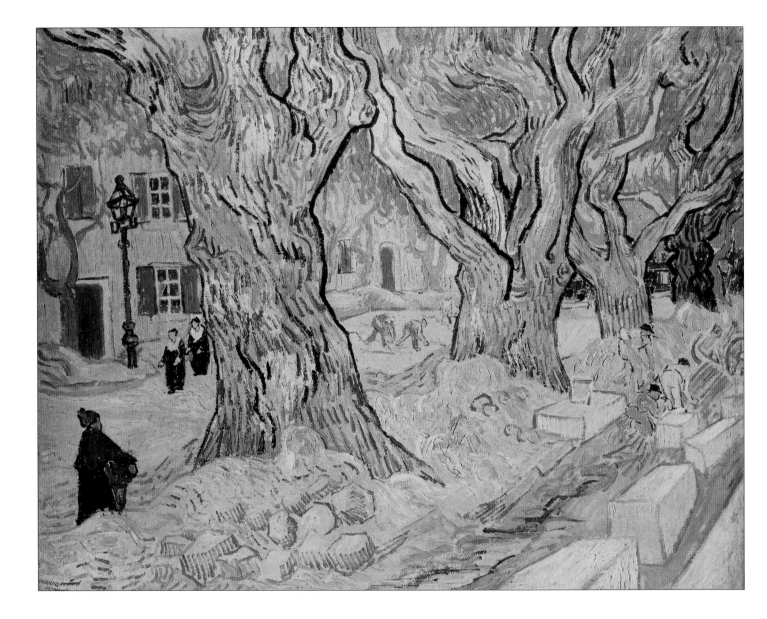

LANDSCAPE WITH GREEN CORN

Plate 48

Oil on canvas. 1889. Narodni Galerie, Prague, Czech Republic.
92 x 74 cm.

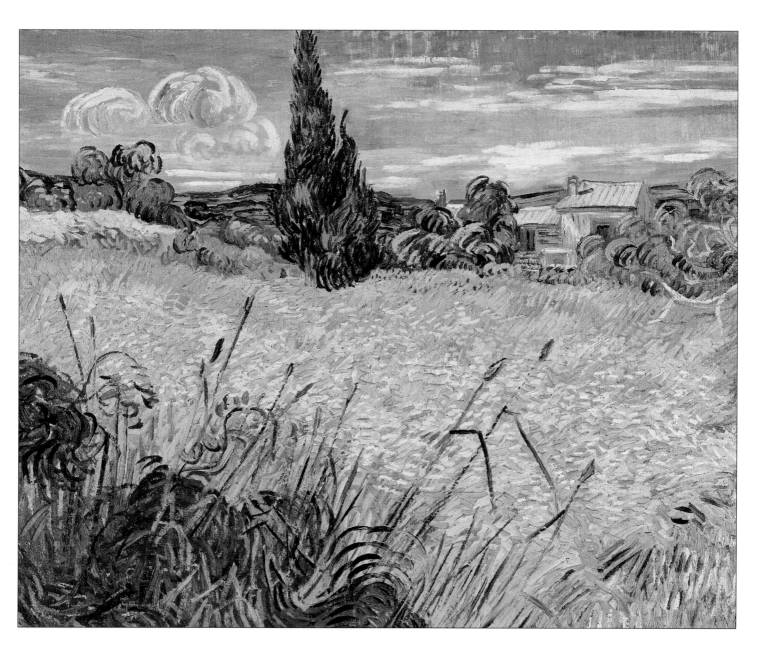

Plate 49

THE ASYLUM GARDEN AT ARLES

Oil on canvas. 1889. Oskar Reinhart Collection, Winterthur, Switzerland.
92 x 73 cm.

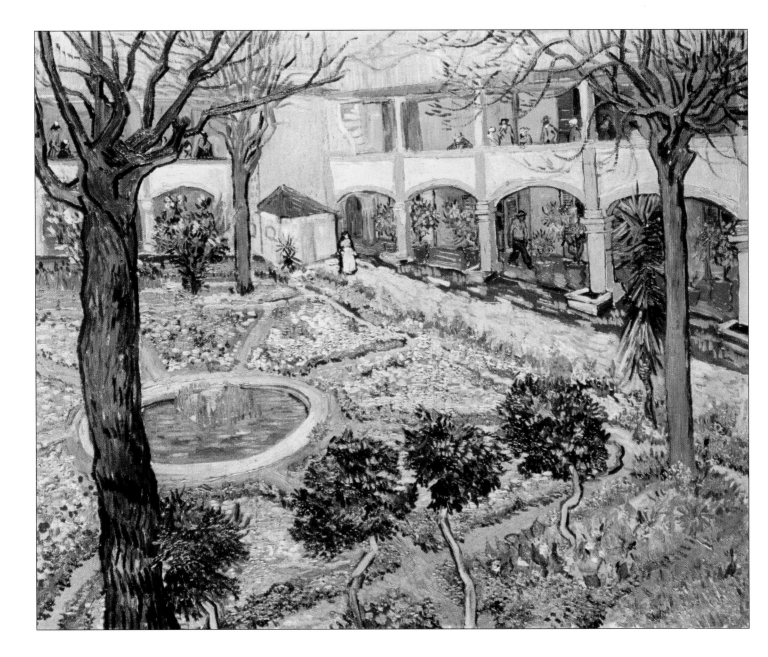

CORN FIELD WITH POPPIES

Plate 50

Oil on canvas. 1889. Kunsthalle, Bremen, Germany.
71 x 91 cm.

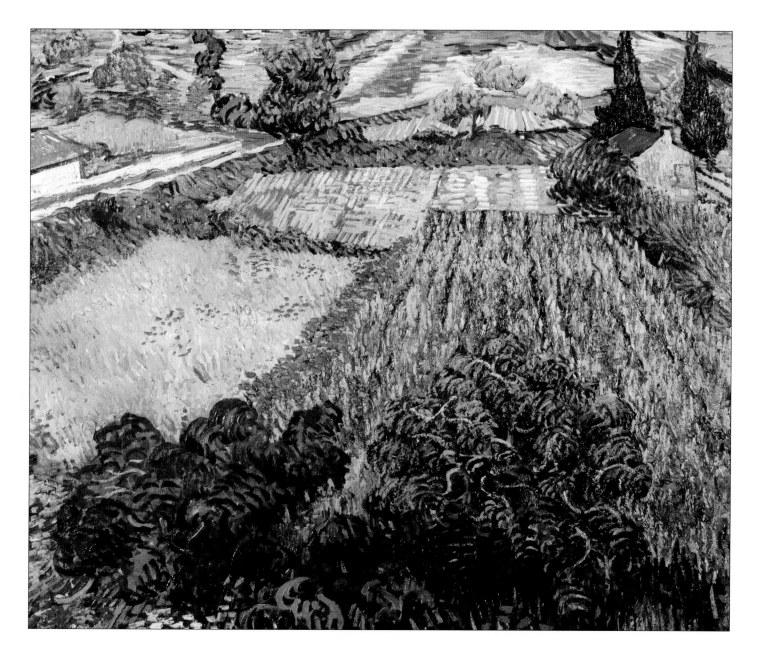

Plate *51*

PEACH BLOSSOM IN THE CRAU

Oil on canvas. 1889. Samuel Courtauld Trust, Courtauld Institute of Art Gallery.
65.5 x 81.5 cm.

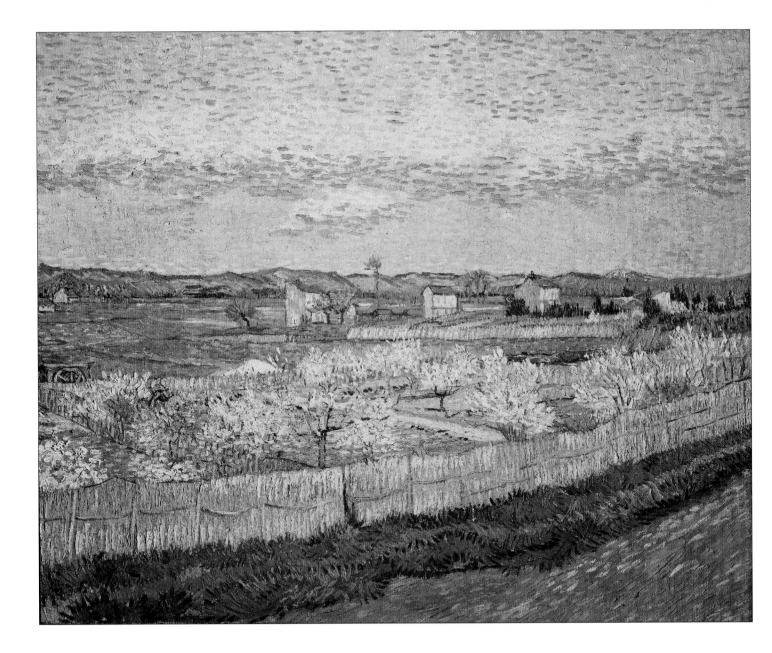

VIEW OF ARLES

Plate 52

Oil on canvas. 1889. Neue Pinakothek, Munich, Germany.
72 x 92 cm.

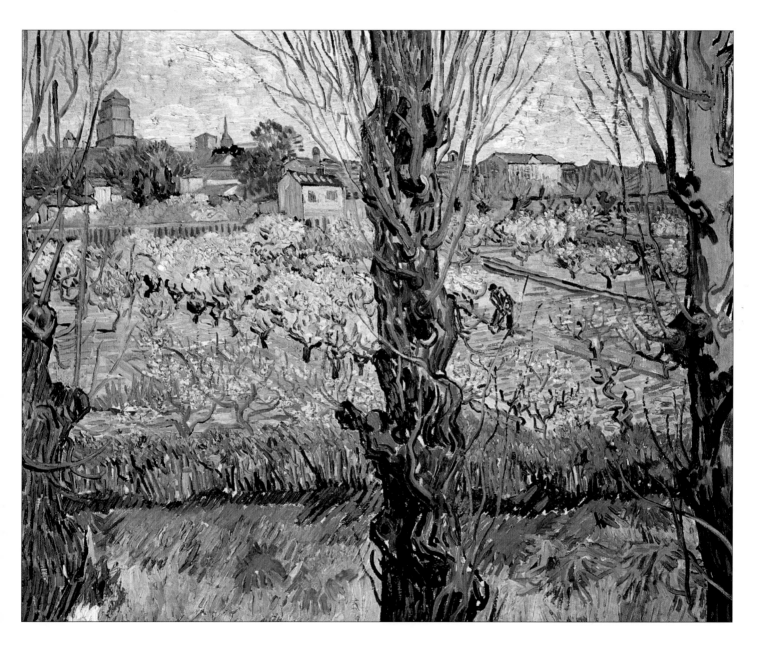

Plate 53

VAN GOGH'S BEDROOM AT ARLES

Oil on canvas. 1889. Art Institute of Chicago, IL, USA.
72 x 90 cm.

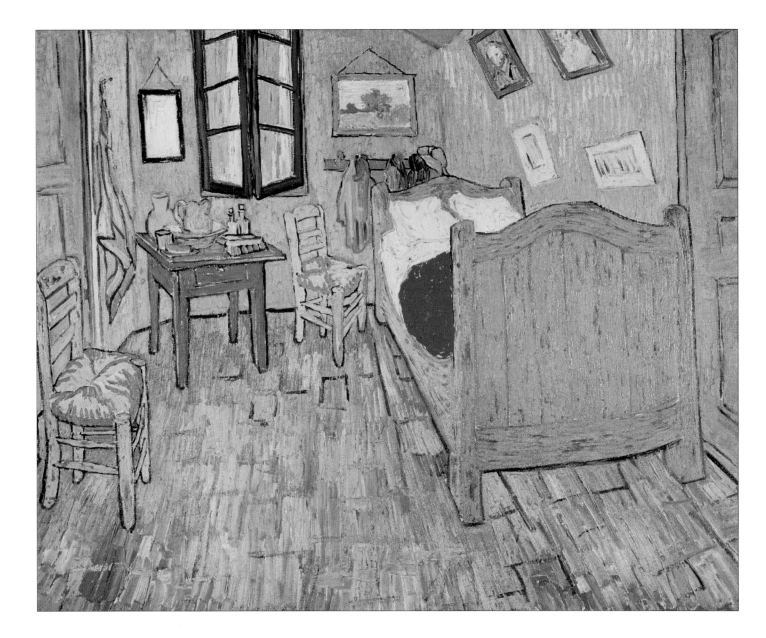

Oil on canvas. 1889. Samuel Courtauld Trust, Courtauld Institute of Art Gallery, London.
60 x 49 cm.

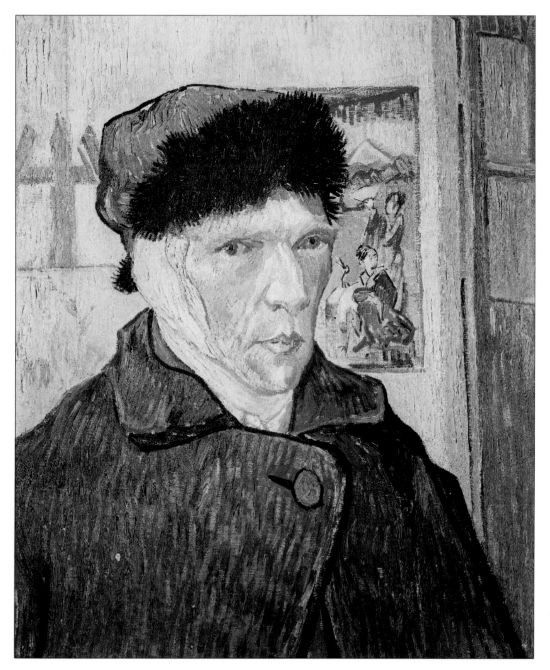

Plate 55

LA BERCEUSE

Oil on canvas. 1889. Private collection. 91 x 71.5 cm.

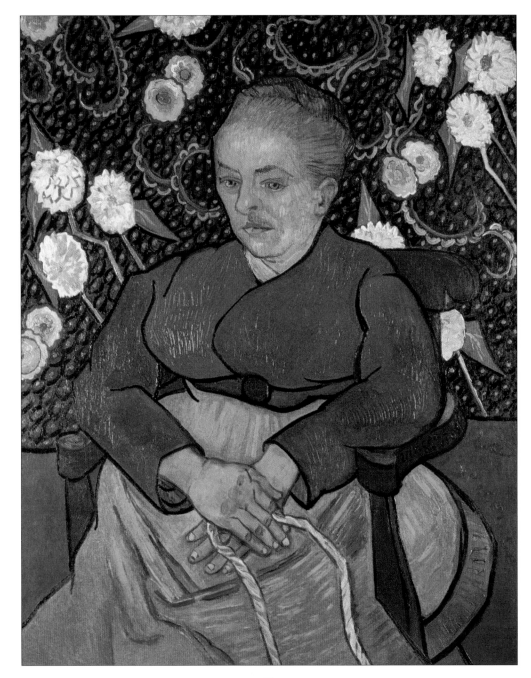

PORTRAIT OF DR FELIX REY

Plate 56

Oil in canvas. 1889. Pushkin Museum, Moscow, Russia. 53 x 64 cm.

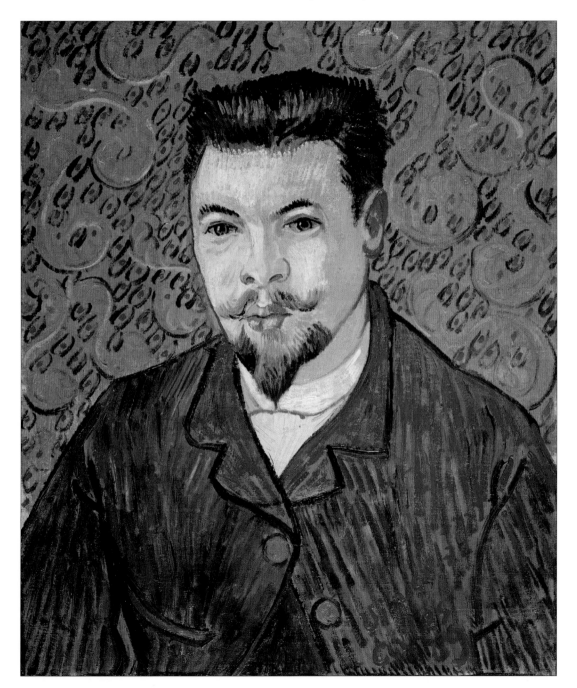

Plate 57

HEAD OF AN ANGEL, AFTER REMBRANDT

Oil on canvas. 1889. Private collection.
54 x 64 cm.

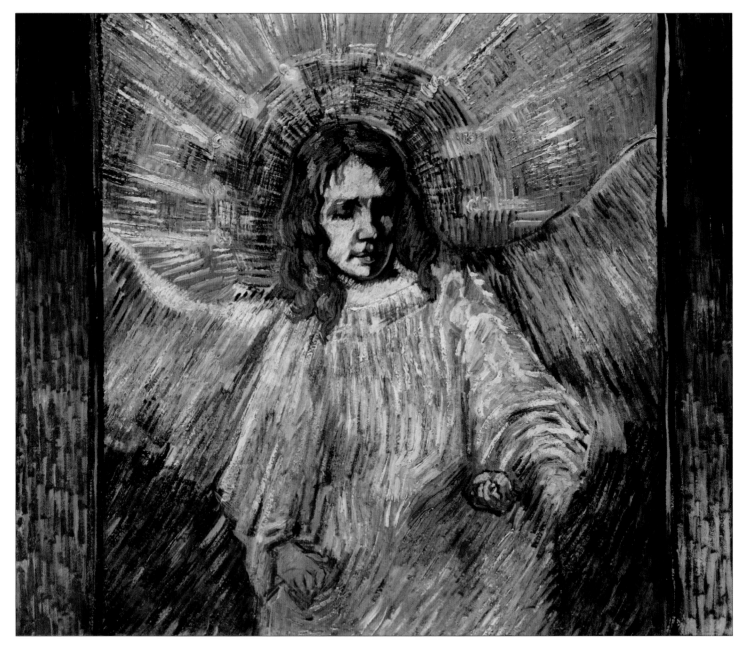

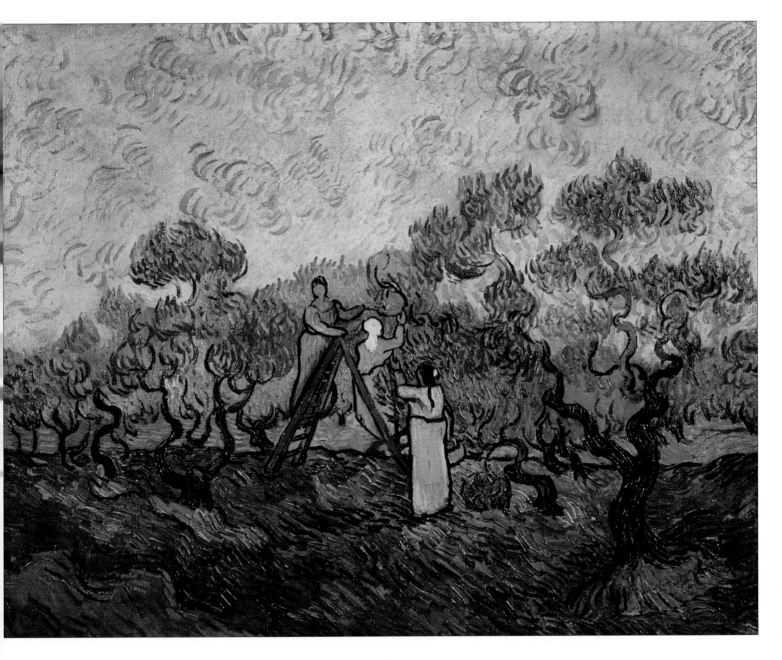

Plate 59

St Paul's Hospital, St Rémy

Oil on canvas. 1889. Musée d'Orsay, Paris, France. 48 x 63 cm.

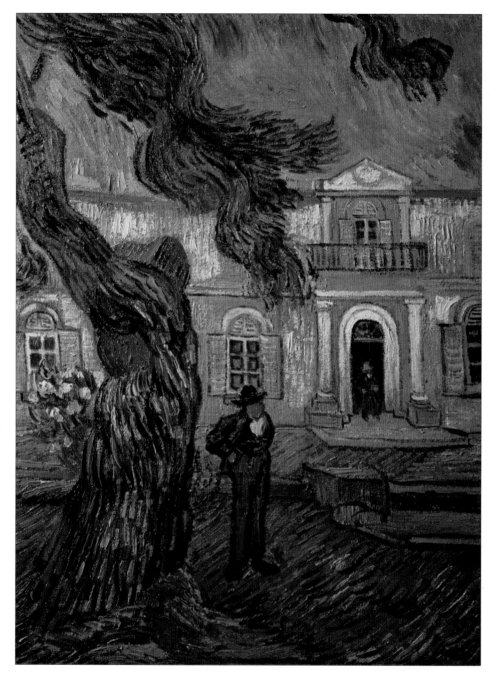

IRISES

Oil on canvas. 1889. J. Paul Getty Museum, Los Angeles, USA.
71 x 93 cm.

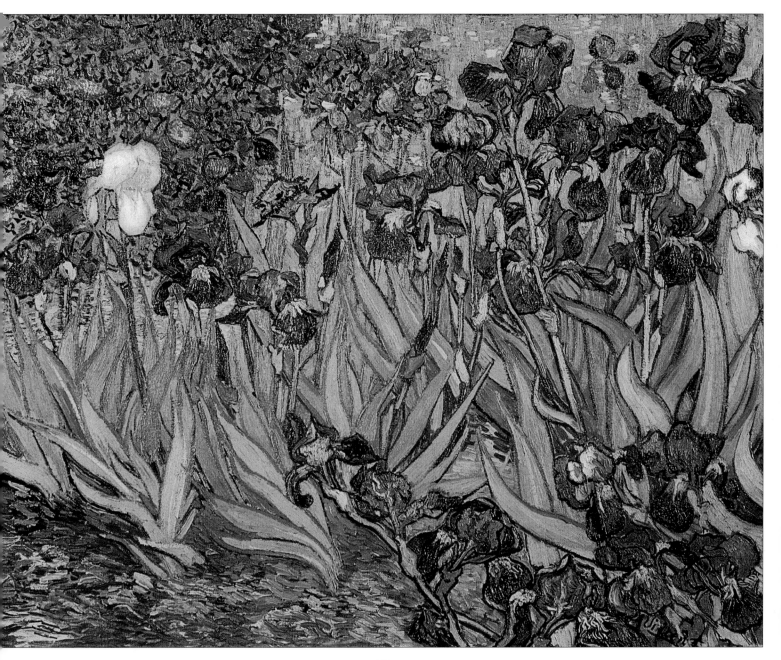

Plate 61

THE STARRY NIGHT

Oil on canvas. 1889. Museum of Modern Art, New York, USA.
73 x 92 cm.

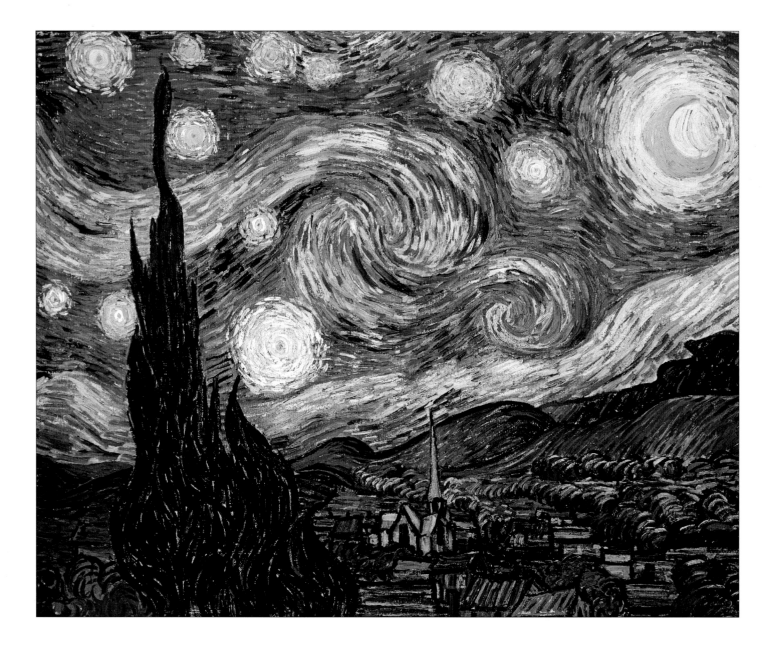

Plate 62

WHEATFIELD WITH CYPRESSES

Oil on canvas. 1889. National Gallery, London, UK.
72.5 x 91.5 cm.

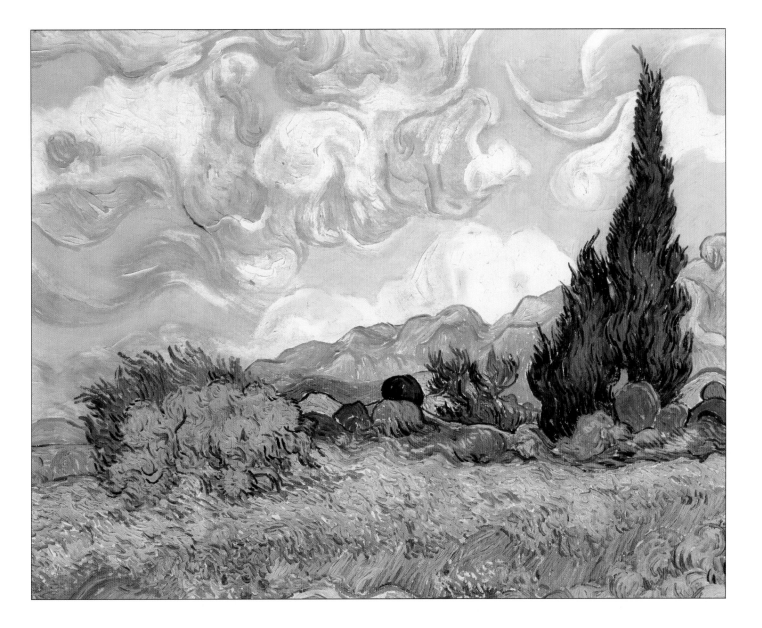

Plate 63

SELF PORTRAIT

Oil on canvas. 1889. Musée d'Orsay, Paris, France. 65 x 54 cm.

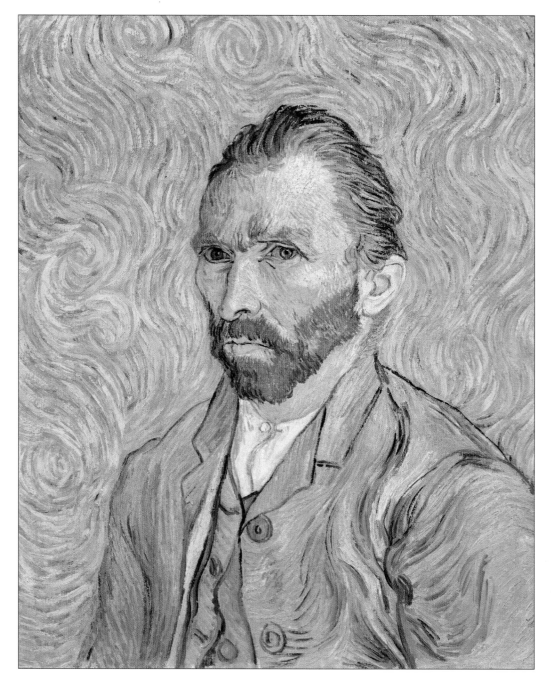

Oil on canvas. 1890. Musée des Beaux-Arts, Lille, France.
65 x 55 cm.

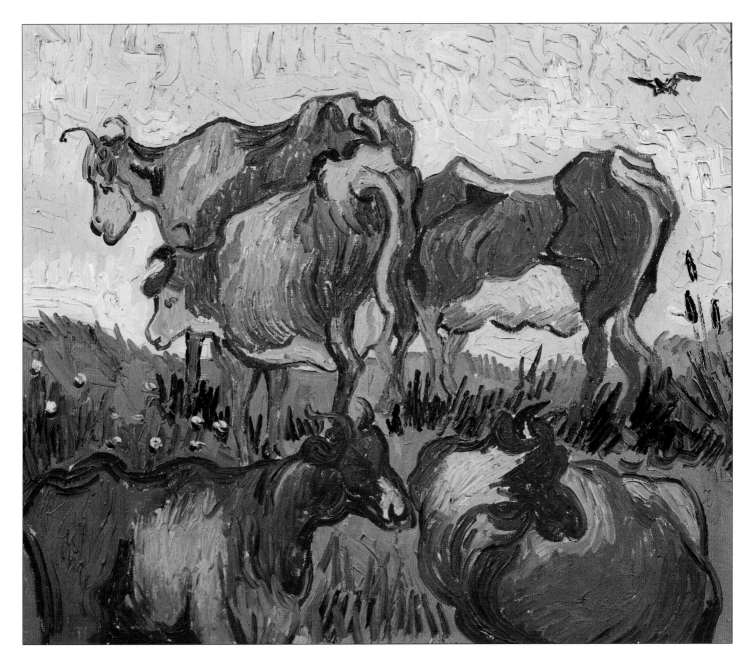

Plate 65

TWO LITTLE GIRLS

Oil on canvas. 1890. Musée d'Orsay, Paris, France. 51 x 51 cm.

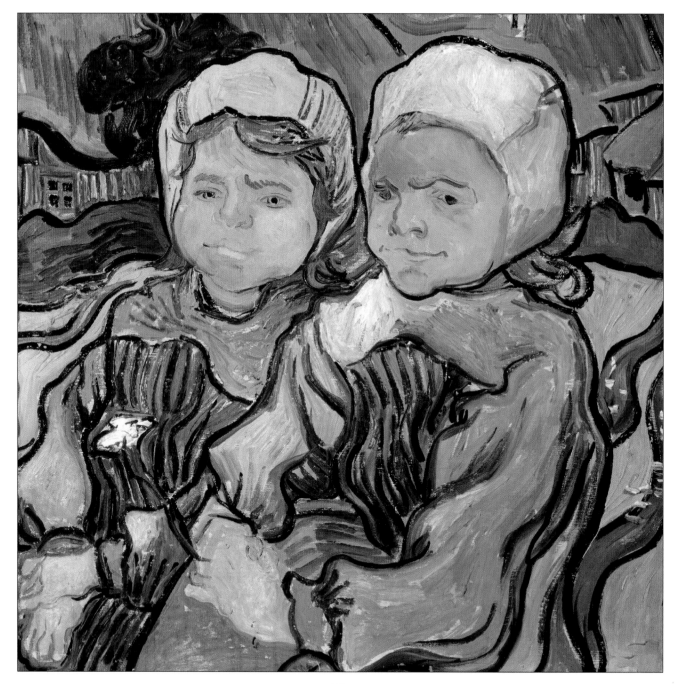

MADEMOISELLE GACHET IN HER GARDEN AT AUVERS–SUR–OISE

Plate 66

Oil on canvas. 1890. Musée d'Orsay, Paris, France. 45 x 55 cm.

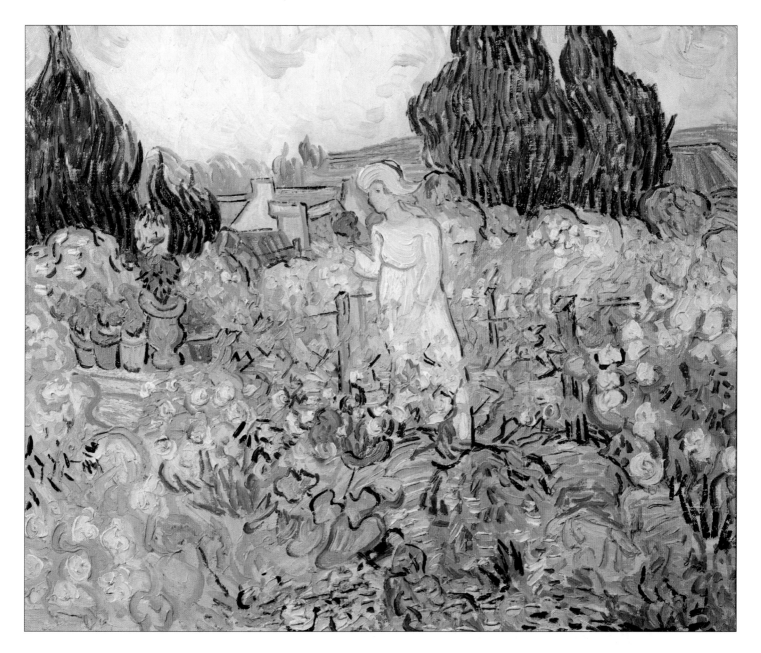

Plate 67

DR PAUL GACHET

Oil on canvas. 1890. Musée d'Orsay, Paris, France.
67 x 56 cm.

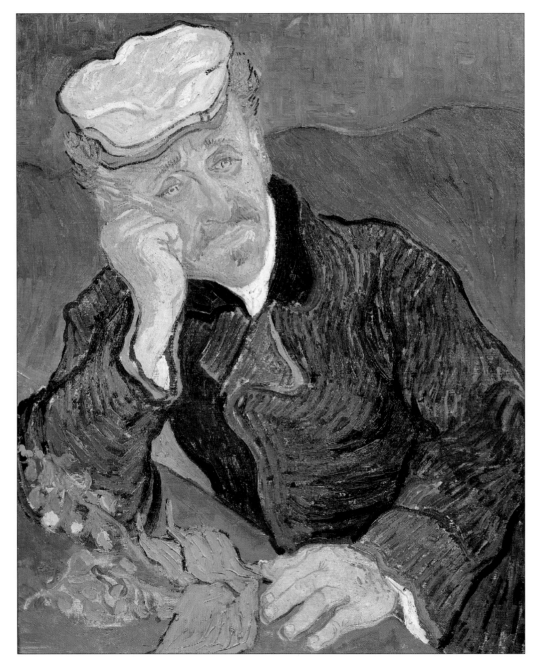

COTTAGES AT AUVERS-SUR-OISE

Plate 68

Oil on canvas. 1890. Hermitage, St. Petersburg, Russia.
73 x 60 cm.

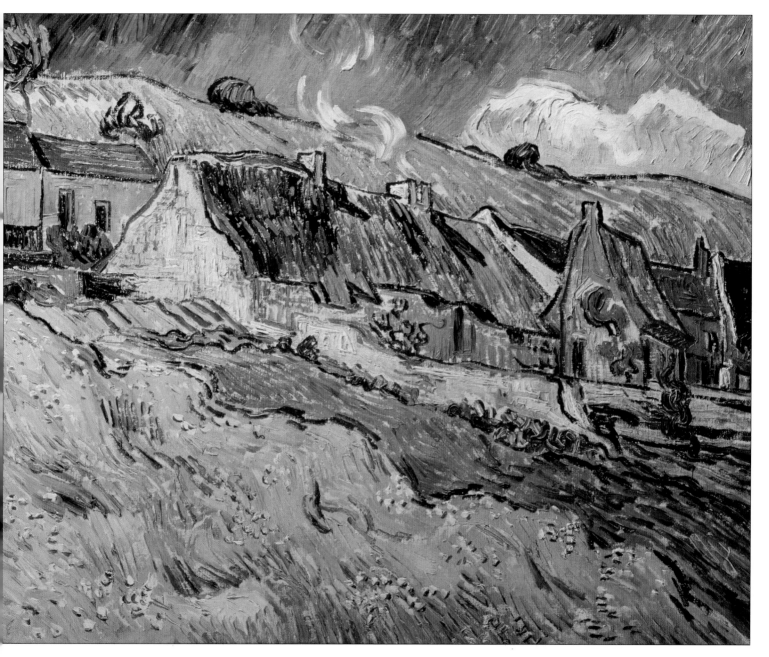

Plate 69

IRISES

Oil on canvas. 1890. Van Gogh Museum, Amsterdam, the Netherlands. 71 x 93 cm.

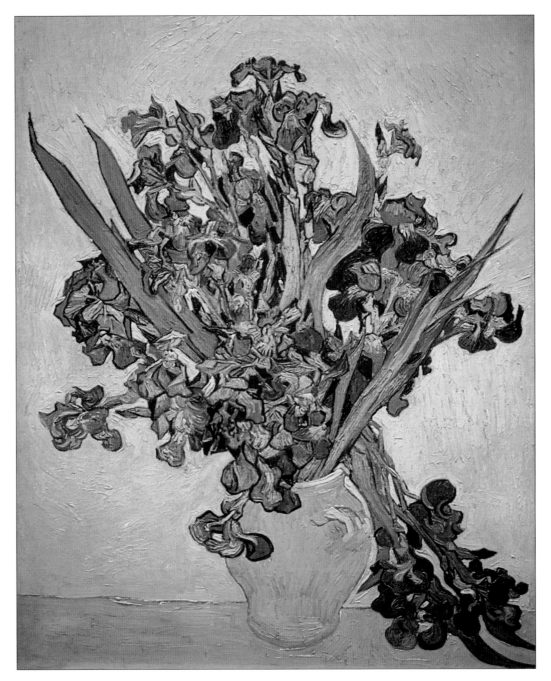

Oil on canvas. 1890. Rijksmuseum Kroller-Muller, Otterlo, the Netherlands. 92 x 73 cm.

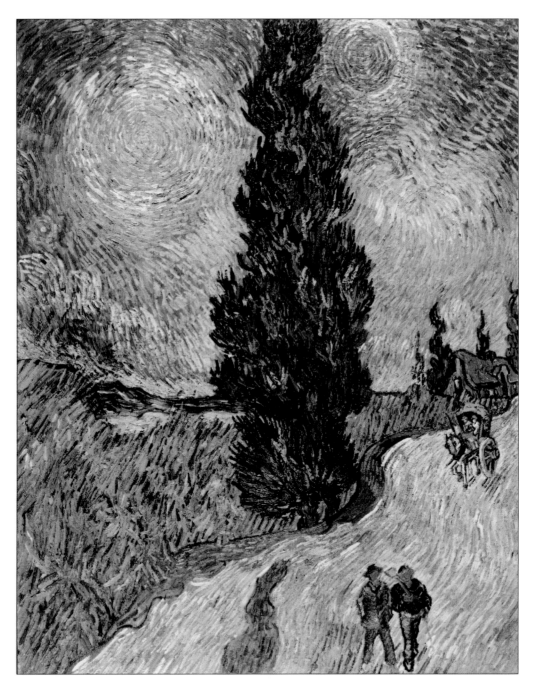

Plate 71

NOON, OR THE SIESTA, AFTER MILLET

Oil on canvas. 1890. Musée d'Orsay, Paris, France.
73 x 91 cm.

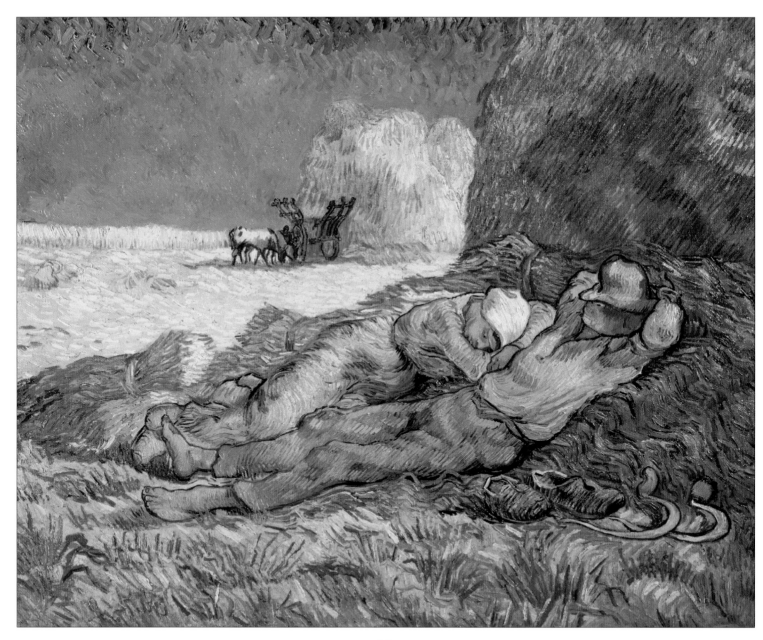

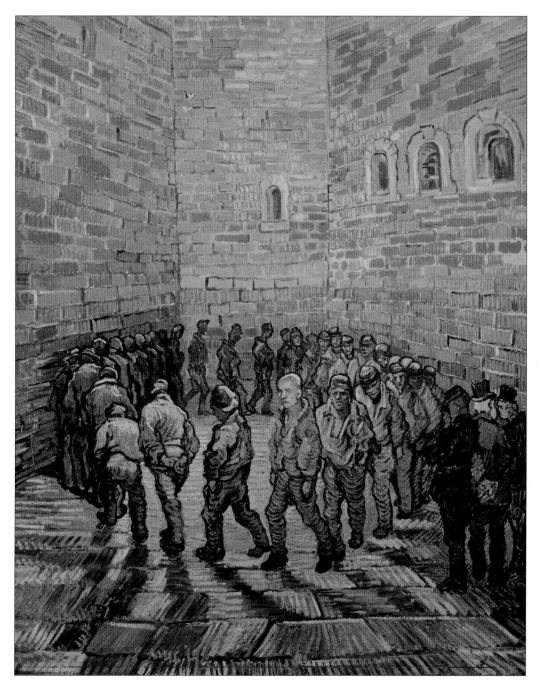

Plate 73

HOUSE AT AUVERS

Oil on canvas. 1890. Museum of Fine Arts, Boston, Massachusetts, USA.
75.6 x 62 cm.

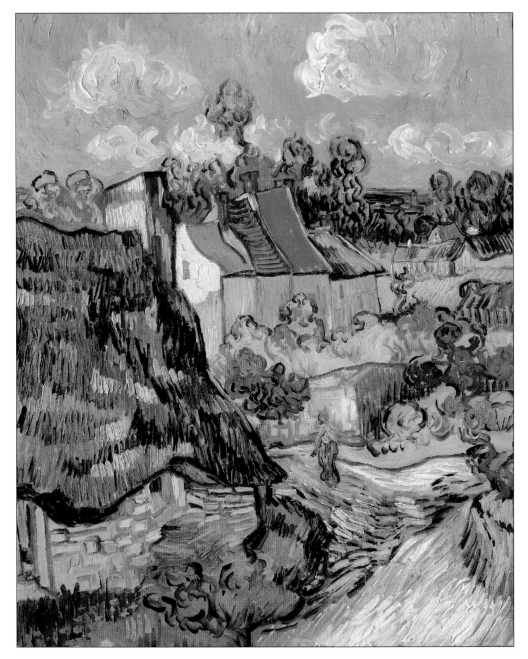

Oil on canvas. 1890. Offentliche Kunstsammlung, Basel, Switzerland. 102 x 50 cm.

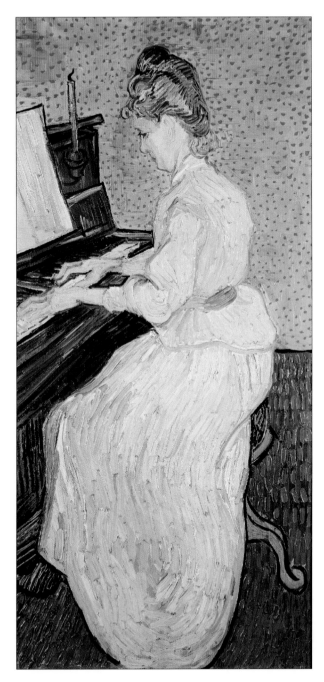

Plate 75 THE GARDEN OF DOCTOR GACHET AT AUVERS–SUR–OISE

Oil on canvas. 1890. Musée d'Orsay, Paris, France. 52 x 73 cm.

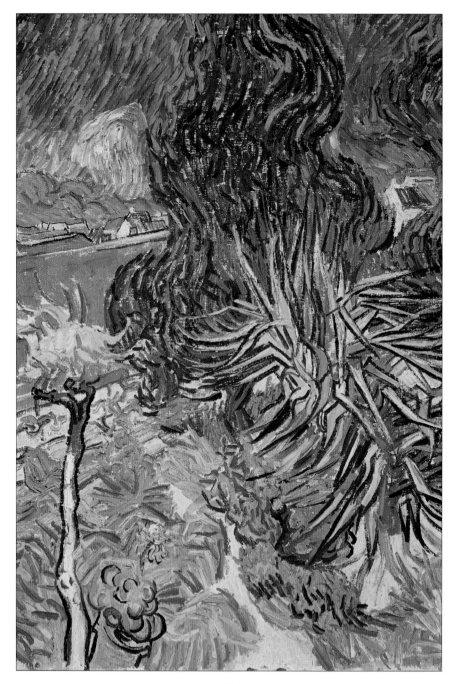

Oil on canvas. 1890. Museum of Finnish Art, Ateneum, Helsinki, Finland. 92 x 73 cm.

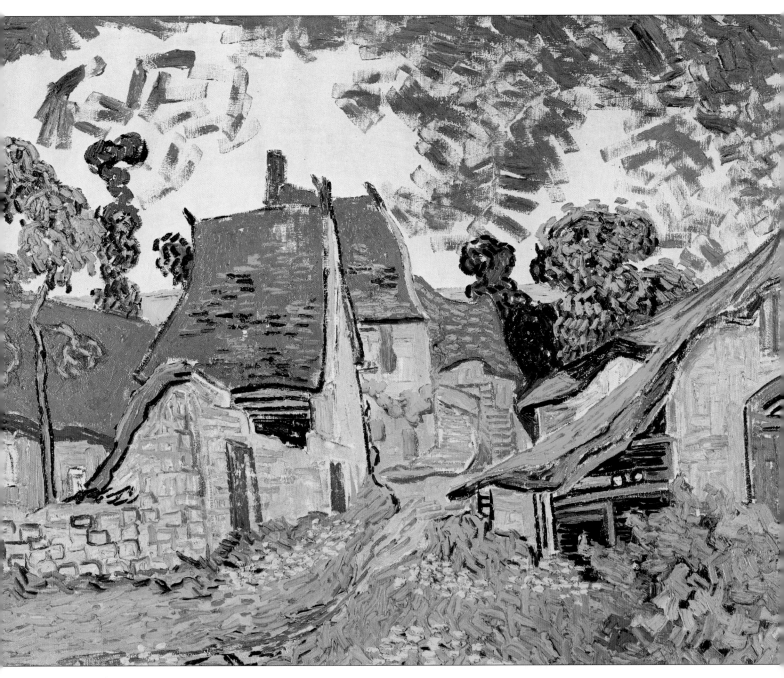

Plate 77

THE CHURCH AT AUVERS–SUR–OISE

Oil on canvas. 1890. Musée d'Orsay, Paris, France. 94 x 74 cm.

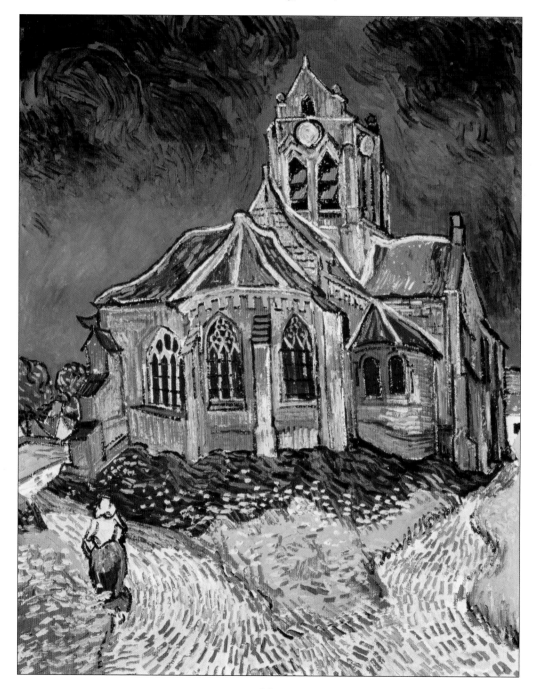

YOUNG PEASANT GIRL IN A STRAW HAT SITTING IN FRONT OF A WHEATFIELD

Plate 78

Oil on canvas. 1890. Private collection. 92 x 73 cm.

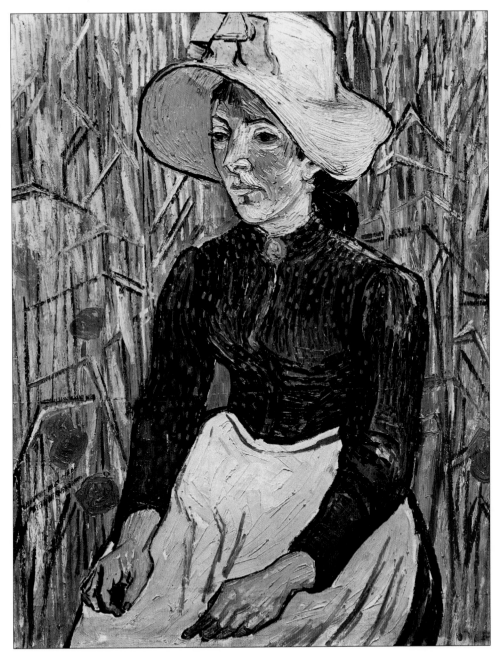

Plate 79

A VASE OF ROSES

Oil on canvas. 1890. Private collection. 71 x 90 cm.

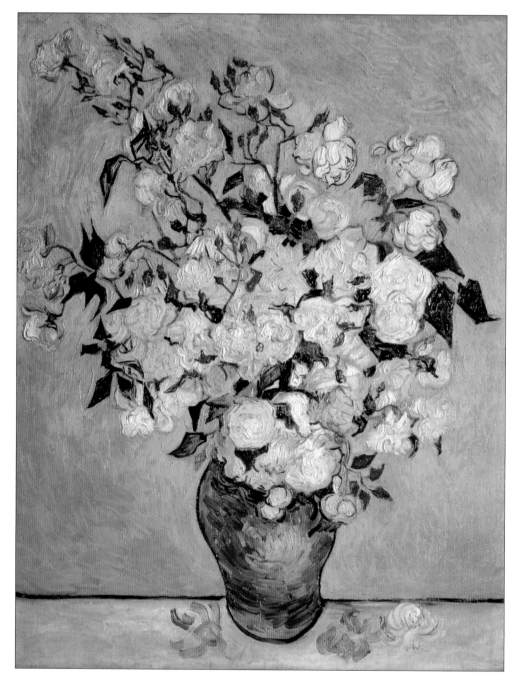

Plate 80

STILL LIFE WITH THISTLES

Oil on canvas. 1890. Private collection. 41 x 34 cm.

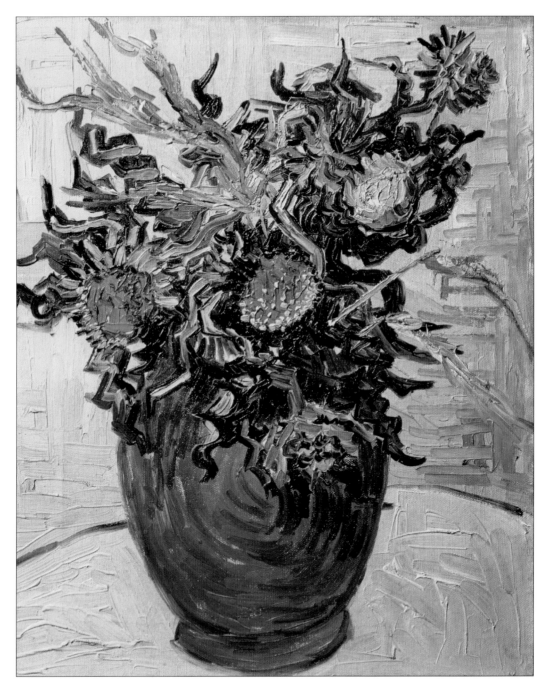

Plate 81

RAIN – AUVERS

Oil on canvas. 1890. National Museum and Gallery of Wales, Cardiff.
50 x 100 cm.

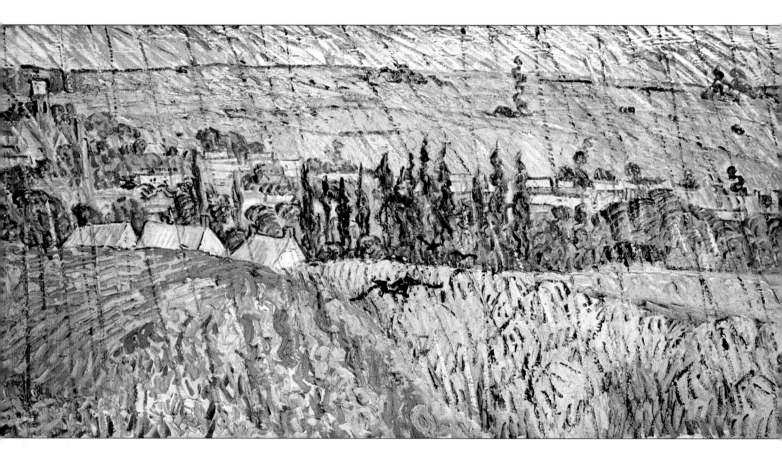

WHEATFIELD WITH CROWS

Plate 82

Oil on canvas. 1890. Van Gogh Museum, Amsterdam, the Netherlands.
50.5 x 103 cm.

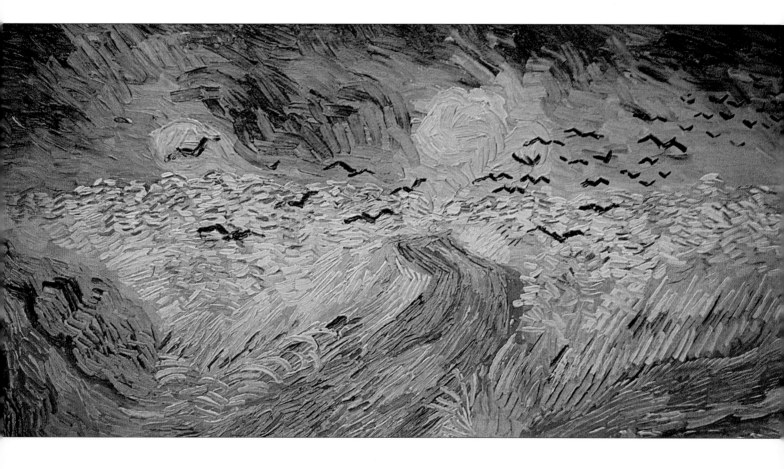

ALPHABETICAL INDEX OF PLATES